IMAGES
of America

# THOREAU'S
# WALDEN

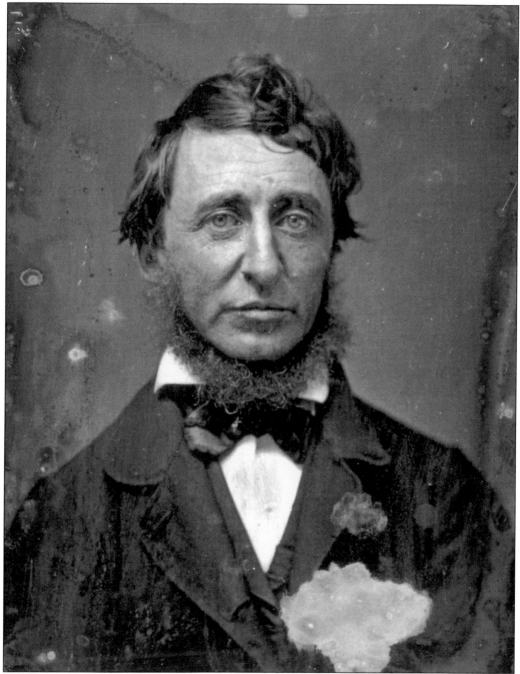

This book is dedicated to the legacy of Henry David Thoreau (1817–1862). Throughout the book, the quotations in italics are by Thoreau except where indicated.

IMAGES
*of America*

# THOREAU'S WALDEN

Tim Smith

ARCADIA
PUBLISHING

Published by Arcadia Publishing
Charleston, South Carolina

Printed in the United States of America

Library of Congress Catalog Card Number: 20021100441

For all general information contact Arcadia Publishing at:
Telephone 843-853-2070
Fax 843-853-0044
E-mail sales@arcadiapublishing.com
For customer service and orders:
Toll-Free 1-888-313-2665

Visit us on the Internet at www.arcadiapublishing.com

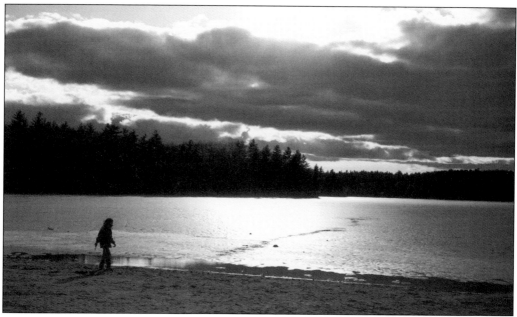

*I wish to speak a word for Nature, for absolute freedom and wildness,
as contrasted with a freedom and culture merely civil . . .*

Walden Pond and Henry David Thoreau: the two names are linked forever by nature and one man's search for divinity. One is the place of inspiration for a literary masterpiece, *Walden; Or, Life In The Woods*, and the other is synonymous with the birth of environmentalism. Thoreau's own eloquent description of Walden Pond, which was his home for two years, is as close to the meaning of spirituality as it is possible to get.

# CONTENTS

# ACKNOWLEDGMENTS

Grateful thanks are extended to all at the Thoreau Society for their support, and to Jeffrey S. Cramer and Jayne Gordon of the Thoreau Institute at Walden Woods and Steve Carlin of the Massachusetts Department of Environmental Management for their assistance with the research.

The images on pages 2, 14, 28, 29, 39, 64, 68, 72, 76, 78–81, 83, 90, 91, and 93 are courtesy of the Thoreau Society of Lincoln, Massachusetts, and the Thoreau Institute at Walden Woods.

The images on pages 52 and 55 are courtesy of the Raymond Adams Collection of the Thoreau Society and the Thoreau Institute at Walden Woods.

The image on page 64 is courtesy of the Walter Harding Collection of the Thoreau Society and the Thoreau Institute at Walden Woods.

# INTRODUCTION

The Walden Pond of Henry David Thoreau was a tranquil place except for the woodland surrounding it, which was being used as a source of firewood for the town of Concord. It is an interesting fact that there are actually more trees in the woods today than there were when Thoreau lived by the pond. He built his house in this particular location because the land was owned by his great friend and mentor Ralph Waldo Emerson, who had bought it for conservation. It was at Emerson's urging, along with that of another close friend Ellery Channing, that Thoreau built the one-room house that would come to define Walden Pond for generations of pilgrims from all over the world. During his "experiment in independent living," Thoreau attempted to seek his personal spirituality through his observation and recording of the natural world and its relationship to the divine.

Thoreau built his 10- by 15-foot house almost entirely himself from materials that he mostly found or was given. The total cost of the construction (as itemized in the "Economy" chapter of Walden) was $28 and 12$^{1}/_{2}$¢. He lived in this house for two years, two months, and two days, moving in on Independence Day, July 4, 1845, and leaving on September 6, 1847.

The literary movement known as Transcendentalism was well established in the nearby town of Concord. Led by Emerson, this gathering of like-minded people in search of the divine but alienated by the strict dogma of organized religion created some of the most stimulating writing of the early 19th century. Besides Emerson and Thoreau, this movement included, at various times, Bronson Alcott and his daughter Louisa, who was then, in 1845, a mere 13 years old, Nathaniel Hawthorne, Margaret Fuller, and many others. Emerson had been ordained as a minister in the Unitarian Church but had left the ministry, later referring to the church as "corpse-cold Unitarianism."

The quest of these great minds was to attempt to find God in nature. Emerson called nature "God with his coat on." It was a progression of this quest that led Thoreau to come to live at Walden Pond.

Unlike most of his fellow Transcendentalists, however, Thoreau had been born in Concord and, in fact, lived there for most of his life. He was born on July 12, 1817, and died prematurely of tuberculosis on May 6, 1862.

His father, John Thoreau (1787–1859), owned a pencil-making factory, and his mother, Cynthia (Dunbar) Thoreau (1787–1872) of Keene, New Hampshire, took in boarders in their various homes to supplement the family's income. Cynthia did not entirely approve of her son living in the woods and made sure he came home for dinner regularly. Thoreau was

*not* a hermit; that was not his purpose. In fact, he had many visitors, perhaps more than he would have liked.

Thoreau's writings are, of course, his most famous legacy, and these writings are closely related to events associated with his hometown. However, at various times he earned his living in a number of different capacities. He was a skilled surveyor, pencil maker, house painter, gardener, inventor, and civil engineer, as well as being an author, poet, teacher, lecturer, and tutor. He tutored Emerson's children and spent a period of time on Staten Island as a tutor to Emerson's brother's children.

During his two years living at Walden, Thoreau did not write the book *Walden* but rather the book that would become his first published work, *A Week On The Concord And Merrimack Rivers* (1849). This was an account of a trip he took with his elder brother John in 1839. *Walden* was written later from a draft made during his stay at the pond and was not published until 1854.

Thoreau was deeply socially conscious and was appalled by the injustices of society. The most contentious issue of his day was, of course, that of slavery. The Transcendentalists were deeply committed to the abolitionist cause, and Thoreau wrote of assisting on the Underground Railroad in Concord. While living at the pond, he spent an infamous night in the Concord jail in 1846 for his continued refusal to pay a poll tax levied by the federal government. Although not specifically antiwar, he would not support the war then being waged in Mexico because it was a territorial war in which land seized by the United States would be more land in which slavery would be legal.

It was this event that gave birth to Thoreau's most famous political essay, *Civil Disobedience* (1849). Originally entitled *Resistance To Civil Government*, this essay became the model for peaceful revolutions employed by Mohandas K. Gandhi, Dr. Martin Luther King Jr., and others.

Concord's other great historical significance is that it saw the beginning of the Revolutionary War in 1775. The "shot heard 'round the world" was fired against the British on April 19. The clerical minister of the town at the time was William Emerson, the grandfather of Ralph Waldo Emerson. He lived then in the Old Manse, one of many famous homes and buildings in Concord, from which he could actually see the start of the battle. It was to this house that Emerson moved when he came to Concord in 1834 and proceeded to gather like-minded people to begin the Transcendental movement.

This would start Concord's second revolution, and when Emerson met Henry David Thoreau, the younger by 14 years, one of the most renowned friendships in American literary history was born. Both men's writings have inspired awe and reverence in many generations of lovers of existential philosophy and beautiful insight. However, it must be said that that was not the case in Thoreau's lifetime; he was considered gifted but a little strange. His sojourn at Walden Pond is only now becoming fully appreciated.

# One

# THE POND

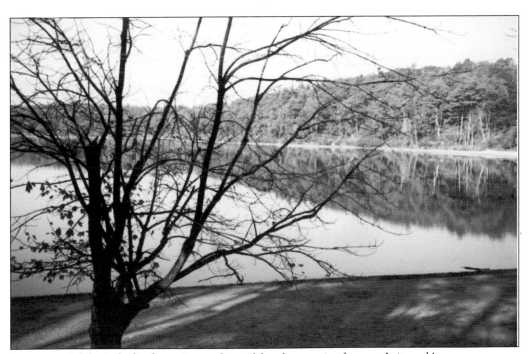

*A lake is the landscape's most beautiful and expressive feature. It is earth's eye;*
*looking into which the beholder measures the depth of his own nature.*

Walden Pond, while technically a lake—61 acres 103 rods, according to Thoreau himself—is a
kettle hole. This means that it is fed from many springs and has no inlet or outlet, which accounts
for its amazing clarity and stillness. Thoreau's survey of the pond gives the circumference as
1.7 miles and the greatest depth as 102 feet.

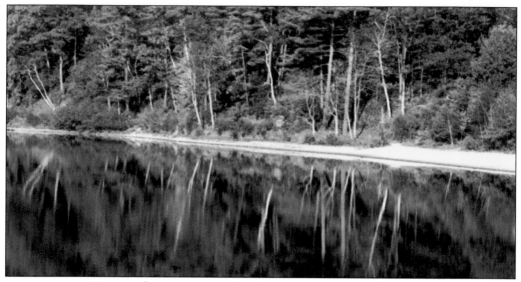

*. . . Nature, who is superior to all styles and ages, is now, with pensive face,
composing her poem Autumn, with which no mark of man will bear to be compared.*

The beauty of Walden Woods is especially stunning when nature turns the trees into a
kaleidoscope of colors during the annual fall spectacular known as autumn. The pond is a haven
for people from all over the world who wish to come and absorb the meditative energy that
so inspired Thoreau.

*If the sun rises on you slumbering, if you do not hear the morning cock-crow,
if you do not witness the blushes of Aurora, if you are not acquainted with Venus
as the morning star, what relation have you to wisdom and purity?*

The essence of the Transcendental movement was the search for God in nature. This
groundbreaking group centered on the person of Ralph Waldo Emerson in the nearby town
of Concord. Emerson became Thoreau's great friend, inspiration, and mentor, and was
instrumental in assisting Thoreau in conducting his experiment at the pond.

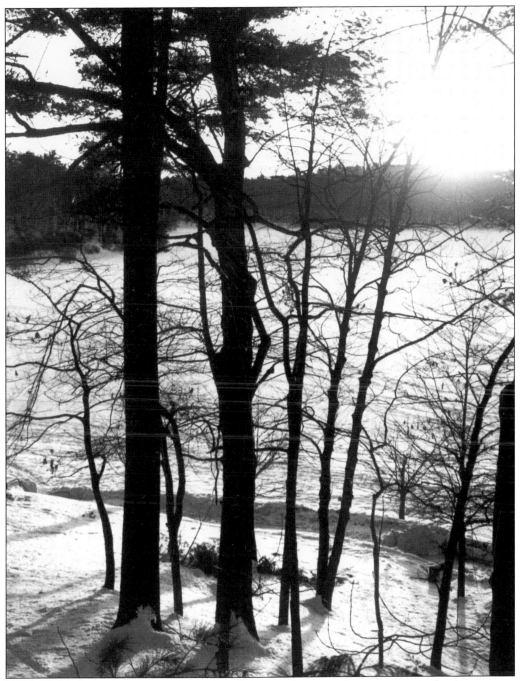

*If there is nothing new on the earth, still the traveler always has a resource in the skies.*
*They are constantly turning a new page to view.*

Thoreau chose Walden Pond for his sojourn in nature because of its tranquility and natural beauty, his observation of which assisted him in his search for and study of divinity. He did not consider his time sitting motionless and observing the natural world to be a waste of his time. This was part of his experiment.

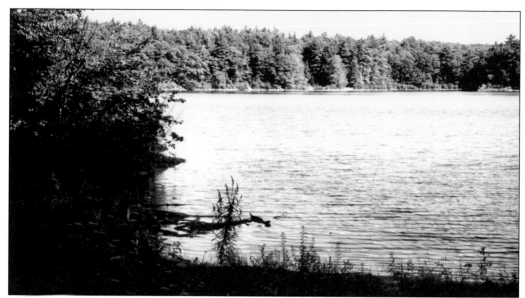

*It takes us many years to find out that nature repeats herself annually.*
*But how perfectly regular and calculable all her phenomena must appear to a mind*
*that has observed her for a thousand years.*

Across the pond to what is now called Thoreau's Cove, the water reflects the "glassy surface of the lake," providing sublime inspiration to Thoreau and all who have followed him. It was on a slope a little above this cove that he built his house on land owned by Emerson.

*He is the man truly—courageous, wise, ingenious—who can use his thoughts and ecstasies*
*as the material of fair and durable creations.*

Walden Pond is now a protected environment within the 411 acres of Walden Pond State Reservation. After many years of unsupervised use, the fragile ecosystems around the pond are being gradually repaired, providing an experience much more compatible with the ideals of Henry David Thoreau. The reservation provides many leisure activities for visitors, including walking, fishing, swimming, and boating.

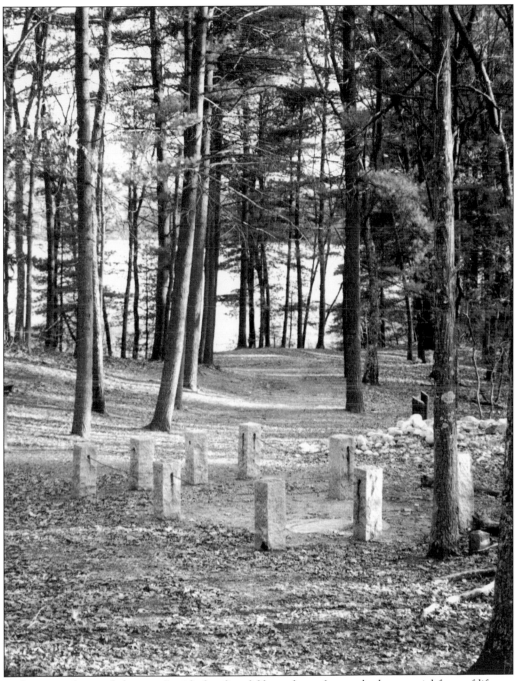

*I went to the woods because I wished to live deliberately, to front only the essential facts of life, and see if I could not learn what it had to teach, and not, when I came to die, discover that I had not lived.*

On this site overlooking Walden Pond, Thoreau built his one-room house in 1845. The house itself was removed in 1847 when he moved back to live in the center of Concord, and the site was not exactly located until 100 years later, in November 1945, by Roland Wells Robbins.

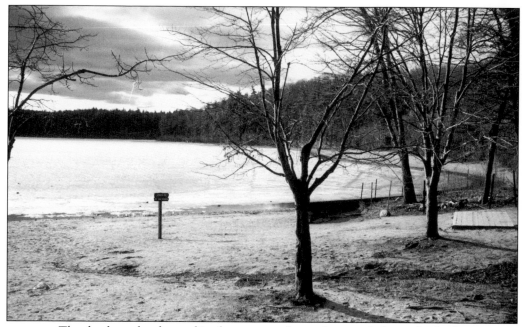

*The clouds are handsome this afternoon: on the north, some dark, windy clouds, rain falling thus beneath.*

The main beach at Walden Pond provides wonderful swimming; the water is always uncannily clear, probably due to its sandy bottom. In 1844, when the railway line between Boston and Fitchburg opened, it brought countless visitors to the pond for recreational activities. This mostly took place on the opposite shore where the Boston & Maine Railroad built an excursion park at Ice Fort Cove in 1866.

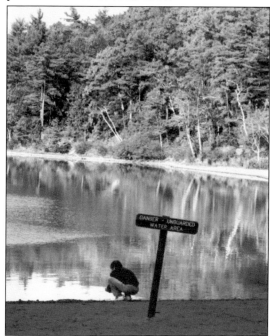

*If a man does not keep pace with his companions, perhaps it is because he hears a different drummer. Let him step to the music which he hears, however measured or far away.*

When the month of October comes to Walden and nature provides a more tranquil atmosphere, people are moved by the spirit of Thoreau. The understanding of spirituality is, by definition, a very personal quest, and the beauty of the pond has quietly inspired generations of artists, writers, poets, photographers, and others.

*When you think that your walk is
profitless and a failure, and you can
hardly persuade yourself not to return,
it is on the point of being a success,
for then you are in that subdued and
knocking mood to which
nature never fails to open.*

The lovely trails through Walden
Woods and around the pond are many
and varied, allowing nature walks and
leisurely strolls. Thoreau spent a large
part of his life walking or sauntering in
Walden Woods and felt it to be the best
thing that he could do with his time.

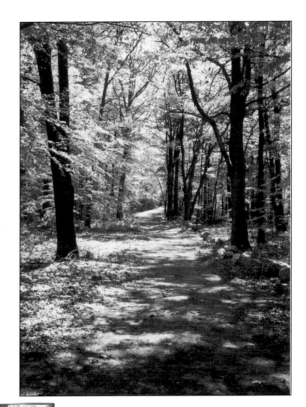

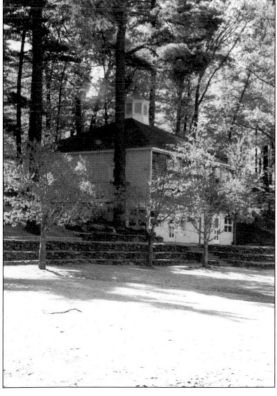

*If you have built castles in the air,
your work need not be lost; that is
where they should be. Now put the
foundations under them.*

Since the fire in 1902 that burned
the railway's excursion park on the
far shore, the only building on the
shores of the pond is this boathouse,
located on the main beach. It is used,
in the summer only, by lifeguards
and for public convenience. The
area around the building is the most
used, and there are paved steps and
walkways. This is the main access
to the trail around the pond.

15

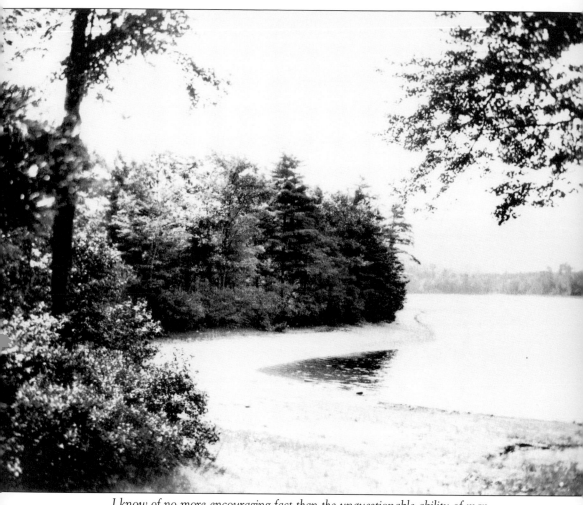

*I know of no more encouraging fact than the unquestionable ability of man
to elevate his life by a conscious endeavor.*

Henry David Thoreau was a man of many talents. He maintained that he needed to work only six weeks in a year to supply all his needs, and he worked in many different occupations during his life. One of his most productive ventures was surveying. He was most accomplished at this and, of course, surveyed Walden Pond in great detail.

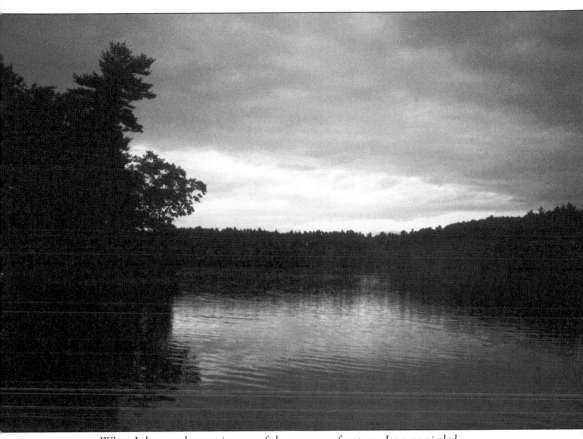

*When I detect a beauty in any of the recesses of nature, I am reminded,*
*by the serene and retired spirit in which it requires to be contemplated,*
*of the inexpressible privacy of a life—how silent and ambitious it is. The beauty*
*there is in mosses must be considered from the holiest, quietest nook.*

One of nature's most expressive tapestries, sunsets with their awesome beauty make us believe in divinity. Observing such natural things and searching for the inherent meaning was what the Transcendentalists aspired to do. Walden provided the perfect place to do so.

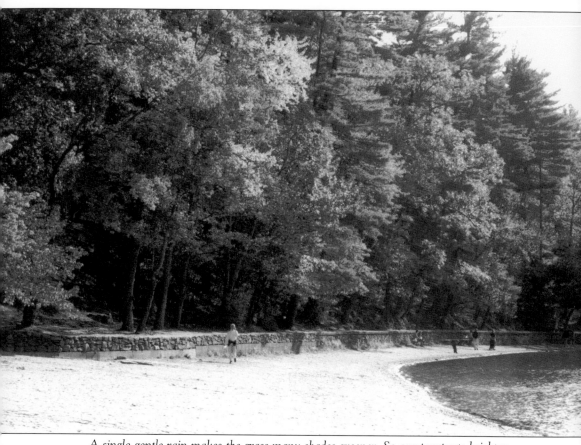

*A single gentle rain makes the grass many shades greener. So our prospects brighten on the influx of better thoughts.*

When the bright greens of summer begin to change to brilliant shades of red, orange, rust, yellow, and a myriad of related colors, Walden takes another step in the eternal cycle of life, death, and rebirth that is nature. Thoreau was continually moved by these events and wrote of them daily in his journal. He started his journal in 1837, after his graduation from Harvard and at the instigation of his friend Ralph Waldo Emerson. He kept the journal almost until his death in 1862, a period of some 25 years. The entries made during his sojourn at the pond became the book *Walden; Or, Life In The Woods*, published in 1854.

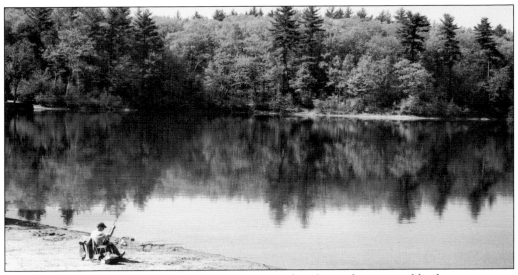

*I learned this, at least, by my experiment; that if one advances confidently
in the direction of his dreams, and endeavors to live the life which he has imagined,
he will meet with a success unexpected in common hours.*

Thoreau asserted that we all need the "tonic of wildness." Native cultures and eastern religions have always understood this and nurtured the earth as one would a biological mother. This is what environmentalism is, as espoused by Thoreau, Emerson, and the other Transcendentalists.

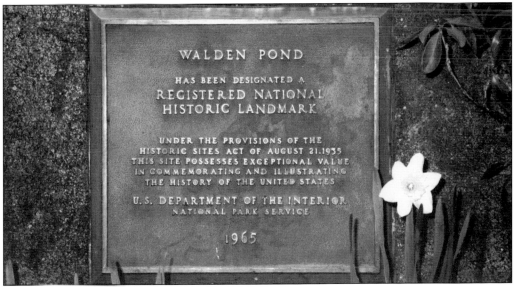

*All things in this world must be seen with the morning dew on them,
must be seen with youthful, early-opened, hopeful eyes.*

One of Walden Pond's many accolades is that it is a registered National Historic Landmark, designated as such in 1965. The designation recognizes Walden Pond for its importance and relevance to American history, especially in the areas of natural beauty and literature, mainly because of Thoreau's book of the same name. The Concord area is also renowned as the part of the country where the Revolutionary War actually started, in 1775.

*It was mythologic, and an Indian might have referred it to a departed spirit. The fiddles made by the trees whose limbs cross one another— played on the wind.*

Winter comes to the pond in earnest in December, when the water usually freezes thick enough to allow skating and ice fishing. In *Walden*, Thoreau writes that the lake froze over completely on December 22, 1845. During winter, the blanket of white snow and ice creates an ethereal atmosphere at the pond, adding to the somewhat bleak solitude of winter, and gives even more inspiration.

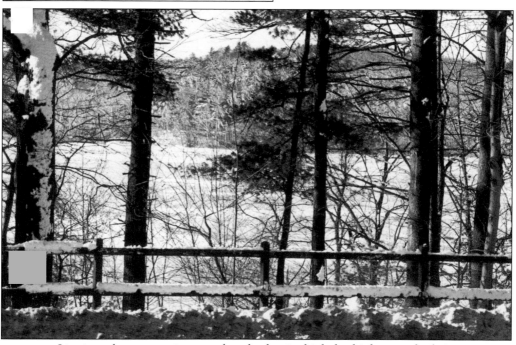

*Live in each season as it passes; breathe the air, drink the drink, taste the fruit, and resign yourself to the influences of each.*

The trees are now bare of foliage and the snow lies thick on the ground; nature is ready to take a rest before the coming rebirth of spring. Walden too, takes a rest. The pond appears even more expansive now with its carpet of white; peace and tranquility now overpower the mind with stillness.

## *Two*

# THOREAU'S HOUSE

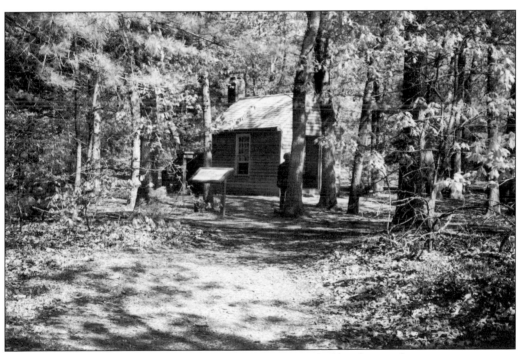

*There is some of the same fitness in a man's building his own house
that there is in a bird's building its own nest.*

Built in 1985, this exact replica of Thoreau's house stands at the entrance to Walden Pond State Reservation. Open to visitors who want to see inside the home and the mind of Thoreau, it is furnished as he had described in *Walden*. It is not, however, on the original site, which makes it accessible to more people. The land that comprises the reservation and surrounds the pond is the area most walked and written about in all of Thoreau's writings and is today managed and protected by the Commonwealth of Massachusetts Department of Environmental Management.

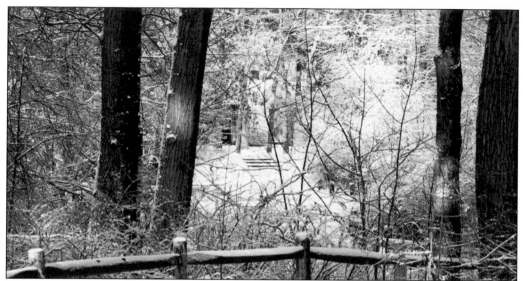

*Nature is full of genius, full of the divinity; so that not a snowflake escapes its fashioning hand.*

This replica of Thoreau's house is one of three erected from his own plans, the famous drawing by Thoreau's sister Sophia, and observations by Roland Wells Robbins, who discovered the site in 1945. Another replica is at the Concord Museum, and the third, which was at Robbins's own house but fell into disrepair, is being reconstructed at the new Thoreau Institute at Walden Woods. In winter, Thoreau's house is almost hidden by the snow-laden trees.

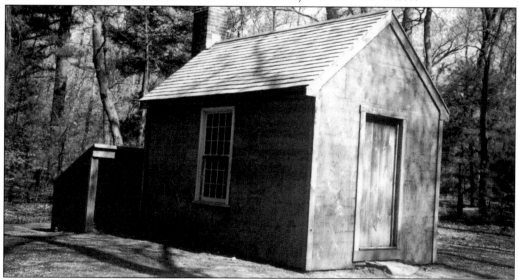

*It is worth the while to have lived a primitive life at some time, to know what are, after all, the necessaries of life and what methods society has taken to supply them.*

Thoreau's house measured 10 feet by 15 feet and was built almost entirely by the labor of his hands with materials he produced from the woods, found, or bought for little cost. He planted vegetables and grew beans in a large bean field close to his home in Walden Woods; these he sold to cover such expenses as he incurred in his everyday life. This is all described in great detail in the "Economy" chapter of *Walden*, published in 1854.

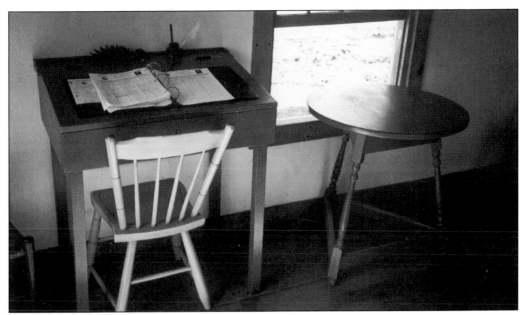

*To my astonishment I was informed on leaving college that I had studied navigation!—why, if I had taken one turn down the harbor I should have known more about it.*

The original desk, chair, and table are now on permanent display at the Concord Museum. At this desk during his two years in the Walden house, Thoreau did not write *Walden* but rather the book that would become his first published work, *A Week On The Concord And Merrimack Rivers* (1849). This book was an account of a trip into nature that he took with his elder brother John in 1839.

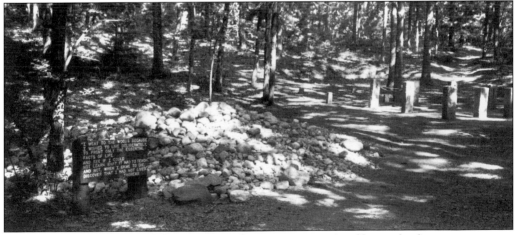

*I never found the companion that was so companionable as solitude.*

The rock cairn that stands a little away from the true location of the cabin was begun in 1872 by Bronson Alcott, one of Thoreau's great friends and admirers and a member of the Transcendental movement. Some 10 years after Thoreau's death, he attempted to mark the site with a makeshift memorial. Since the discovery of the chimney foundation, which precisely marks the cabin site, the cairn has been moved slightly. For 130 years, the cairn has been a place for people to add a stone in homage to what Thoreau accomplished here.

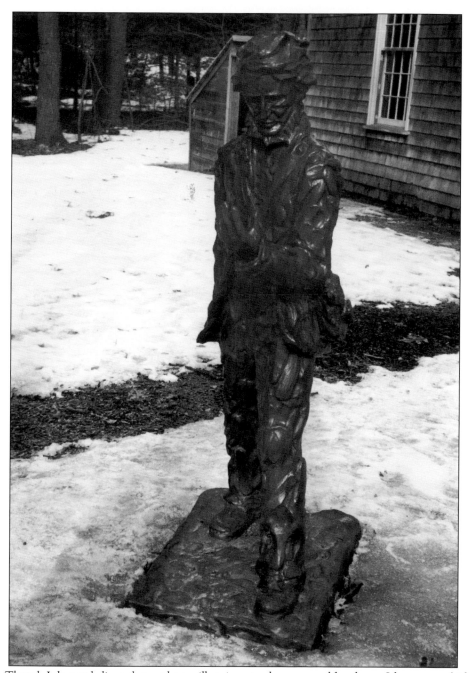

*Though I do not believe that a plant will spring up where no seed has been, I have great faith in a seed . . . Convince me that you have a seed there, and I am prepared to expect wonders.*

This bronze statue of Henry David Thoreau stands outside the house replica by the shores of Walden Pond. The statue seems to guard the house from encroaching civilization. It is only right that he should be memorialized here, as his experiment in living and the book about that experiment have now passed into American literary history.

*My profession is to be always on the alert to find God in nature, to know his lurking-places, to attend all the oratorios, the operas, in nature.*

Still here today, the Boston & Maine Railroad opened the Boston to Fitchburg line in 1844, one year before Thoreau built his house. The line runs directly along the shore of the pond, and into the town of Concord, Thoreau's hometown. He made friends with the Irish crews that built the line and even purchased materials from them for his house. He would walk along the railway line into town frequently to socialize or to have dinner at home with his family.

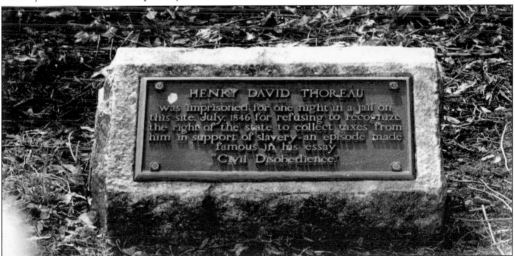

*The law will never make a man free; it is men who have got to make the law free. They are the lovers of law and order, who observe the law when the government breaks it.*

This marker, in the very center of Concord, designates the site of the jail in which Thoreau spent a night in 1846, midway through his sojourn at the pond. He had steadfastly refused to pay a poll tax levied by the federal government because he would not support the government's waging of a territorial war in Mexico at that time. He was not specifically against war but could not condone the fact that slavery would be legal in any land gained by the United States. This action of peaceful resistance became the basis for arguably his most famous essay, *Civil Disobedience* (originally published as *Resistance To Civil Government* in 1849).

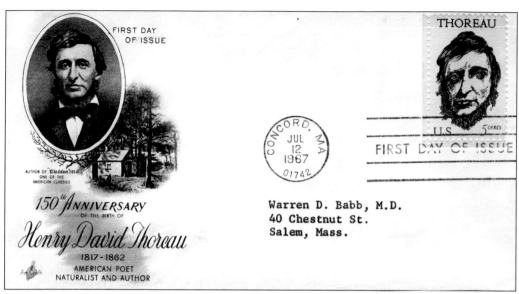

FIRST DAY
OF ISSUE

AUTHOR OF *Walden* 1854
ONE OF THE
AMERICAN CLASSICS

150ᵗʰ ANNIVERSARY
OF THE BIRTH OF

*Henry David Thoreau*

1817–1862
AMERICAN POET
NATURALIST AND AUTHOR

CONCORD, MA
JUL 12 1967
01742

THOREAU

U.S. 5 cents

FIRST DAY OF ISSUE

Warren D. Babb, M.D.
40 Chestnut St.
Salem, Mass.

*Read the best books first, or you may not have a chance to read them at all.*

This first-day-of-issue stamp commemorates Thoreau on the 150th anniversary of his birth in Concord in 1817. Remembered as an American writer, naturalist, and man of many talents, he lived a sadly shortened life, dying of tuberculosis—a disease that is said to have killed half the people in New England in the early 19th century. He died peacefully in his sister Sophia's arms at home in Concord at the age of 44. The stamp design is by Leonard Baskin (1922–2000).

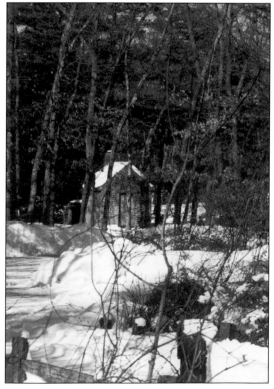

*Measure your health by your sympathy
with morning and spring, and if the warble
of the first bluebird does not thrill you,
know that the morning and spring
of your life are past.
Thus you may feel your pulse.*

Thoreau's *Walden*, published in more than 100 different editions and in many other languages, and his journal of nearly two million words reflect his idealistic philosophy, his belief in the dignity of men, and his love of nature.

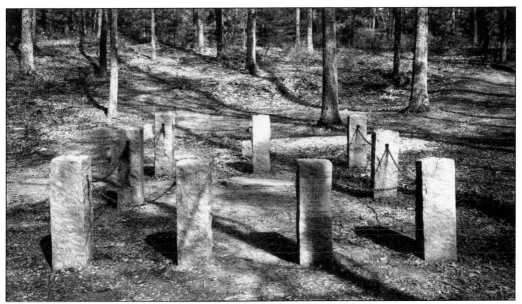

*I think that each town should have a park, or rather a primitive forest, of five hundred or a thousand acres, either in one body or several—where a stick should never be cut for fuel— nor for the navy, nor to make wagons, but stand and decay for higher uses—a common possession forever, for instruction and recreation.*

This is the actual site of Thoreau's house, marked by granite pillars. The doorway is open so people can see the stone marker placed over the chimney foundation, the discovery of which identified precisely the location about 100 feet up the slope from the pond.

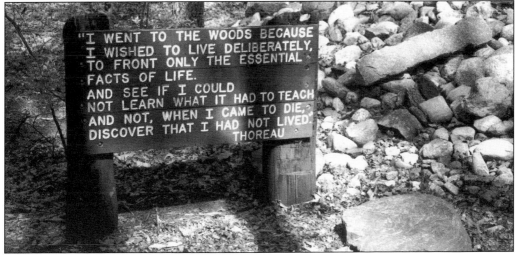

*In proportion as he simplifies his life, the laws of the universe will appear less complex, and solitude will not be solitude, nor poverty poverty, nor weakness weakness.*

Thoreau wrote on many subjects during his short but prolific life. He is perhaps best known for his writings on the natural world and man's role therein. The two years he lived in his little house by the pond were very productive in this area. He thought it was a fine use of his time to sit peacefully for hours watching nature work her magic.

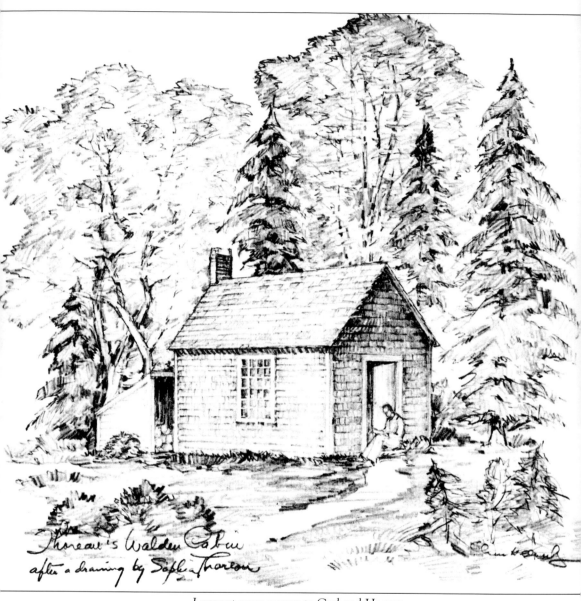

*Thoreau's Walden Cabin*
*after a drawing by Sophia Thoreau*

*I cannot come nearer to God and Heaven*
*Than I live to Walden even.*
*I am its stony shore,*
*And the breeze that passes o'er;*
*In the hollow of my hand*
*Are its water and its sand . . .*

This drawing of Thoreau's Walden cabin was done by Charles Overly, based on a sketch by Sophia Thoreau.

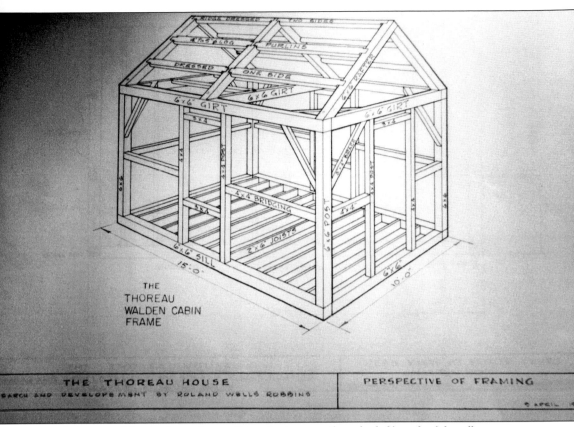

THE
THOREAU
WALDEN CABIN
FRAME

THE THOREAU HOUSE
RESEARCH AND DEVELOPEMENT BY ROLAND WELLS ROBBINS

PERSPECTIVE OF FRAMING

*I was seated by the shore of a small pond, about a mile and a half south of the village*
*of Concord and somewhat higher than it, in the midst of an extensive wood*
*between that town and Lincoln, and about two miles south*
*of that our only field known to fame, Concord Battle Ground . . .*

These very detailed plans of Thoreau's house are available to all and are quite sufficient
to enable anyone, who so wished, to build a replica. Thoreau himself, in his capacity as a
surveyor, left the dimensions, and Roland Wells Robbins developed the plans from his research
conducted while trying to locate the house site.

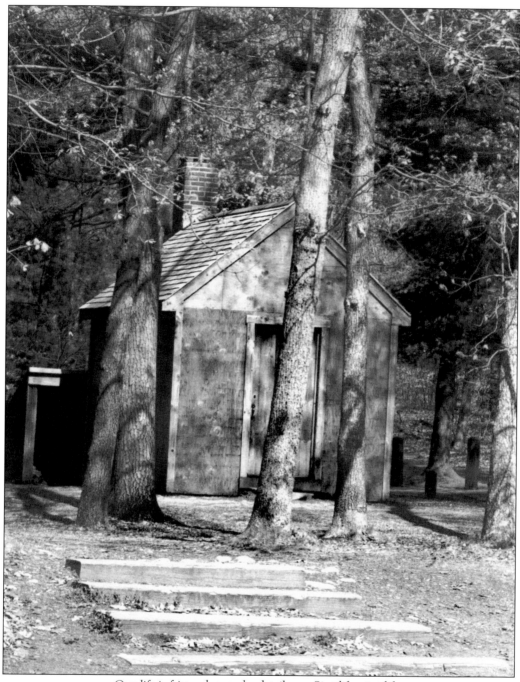

*Our life is frittered away by detail . . . Simplify, simplify.*

Thoreau came to the woods in an attempt to simplify his life, believing that this was the way to reach spiritual awareness. Often dismissed during his lifetime as gifted but a little strange, he was not at all understood in puritanical New England for his ideas on religion. Mankind is more aware today because of Thoreau's teaching.

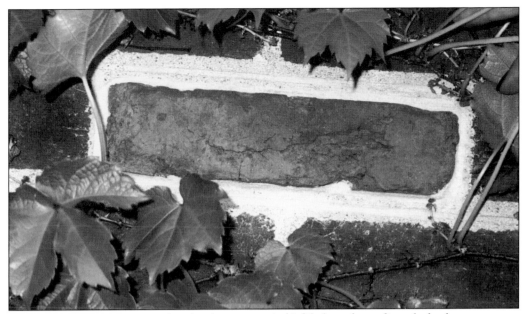

*How many a man has dated a new era in his life from the reading of a book.*

This is an original brick from Thoreau's Walden house—a very precious item. It is situated here in the wall of the new Thoreau Institute at Walden Woods, a research and educational facility created as a joint venture between the Thoreau Society and the Walden Woods Project. The Thoreau Institute replaced the old Thoreau Lyceum in Concord and now stores the largest collection of original Thoreau material in the world, including the donated collections of Walter Harding, Roland Wells Robbins, and Bradley P. Dean.

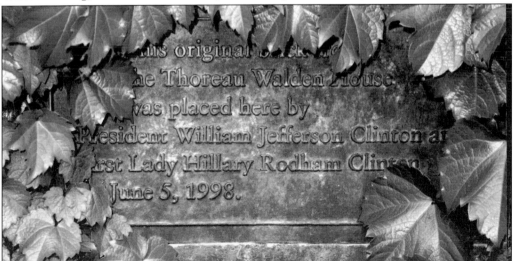

*Our village life would be stagnate if it were not for the unexplored forests
and meadows which surround it. We need the tonic of wildness . . .*

This plaque is under the Walden house brick, commemorating the opening of the new Thoreau Institute at Walden Woods on June 5, 1998, by the placing of the last brick by President William Jefferson Clinton and First Lady Hillary Rodham Clinton.

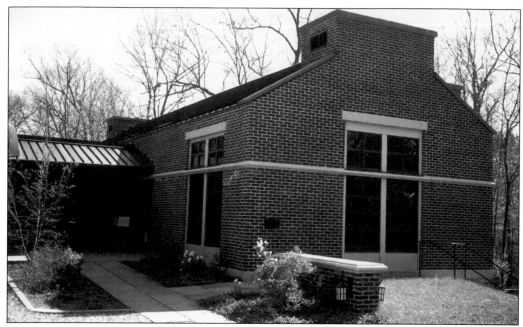

*The earth I tread on is not a dead, inert mass. It is a body, has a spirit, is organic, and fluid to the influence of its spirit, and to whatever particle of that spirit is in me.*

The Thoreau Institute at Walden Woods was built to environmentally sound specifications, using many recycled materials, so as to adhere to the principles about which Thoreau was so passionate. The archival materials are housed in a climate-controlled vault because of their age and fragile condition, and the Thoreau Institute is open to anyone by appointment for the purposes of research and education.

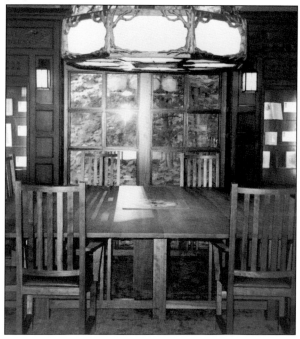

*Nowadays almost all man's improvements, so called, as the building of houses and the cutting down of the forest and of all large trees, simply deform the landscape, and make it more and more tame and cheap.*

The Henley Library was named after musician Don Henley, founder of the Walden Woods Project. Henley had spent time at Walden Pond, appreciated the natural beauty and spirituality of the land, and is an admirer of Thoreau and his writings. When the woods surrounding the pond were threatened with development in the late 1980s and early 1990s, he stepped in and founded a movement to save the woods by raising the money necessary to buy the land for conservation.

*Heaven is under our feet as well as
over our heads.*

Walden Woods is the precious land of
Thoreau and Emerson. Thoreau would
think nothing of walking eight or ten
miles to "keep an appointment with
a beech tree." He and his good friend
Emerson, sometimes with others of the
Transcendental group, would walk through
the woods discussing matters of high
importance and be at one with nature. In
his most beautiful essay, *Walking*, Thoreau
used the word "sauntering," which referred
to walking for the sake of it. It is taken
from the French phrase *Saint Terre*,
meaning "Holy Land." In the Middle
Ages, people would wander the land in
search of the Holy Land, hence *Saint
Terre*, or saunterer.

*One attraction in coming to
the woods to live was that I
should have leisure and opportunity
to see the spring come in.*

Thoreau possessed an amazing eye
for detail. He was able to walk in the
woods and identify and record every
natural thing that he encountered. His
knowledge of the flora and fauna and
the recording of it in his journal were
the basis for most of his wonderful
essays on the natural world.

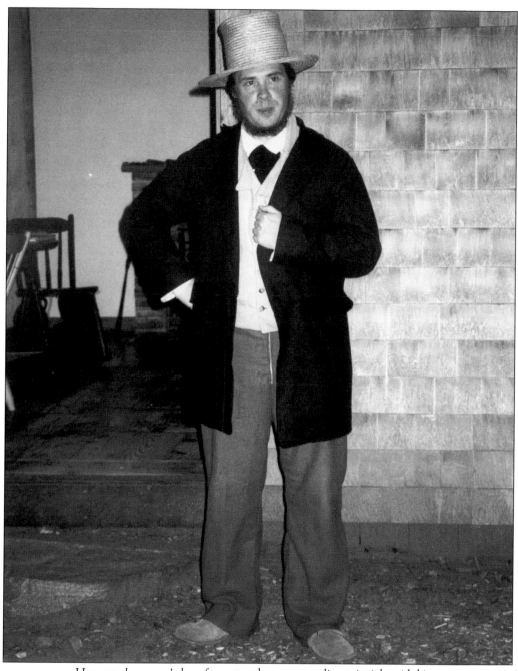

*How rarely a man's love for nature becomes a ruling principle with him,*
*like a youth's affection for a maiden, but more enduring! All nature is my bride.*

The man himself! Thoreau, portrayed by Concord living historian Richard Smith, hosts regular meetings at his Walden house throughout the year. Henry David Thoreau was a writer, surveyor, teacher, environmentalist, poet, adventurer, tutor, house builder, and pencil maker; he was indeed a man of many talents. He lived in his Walden house for two years, two months, and two days, moving in on July 4, 1845, and leaving on September 6, 1847.

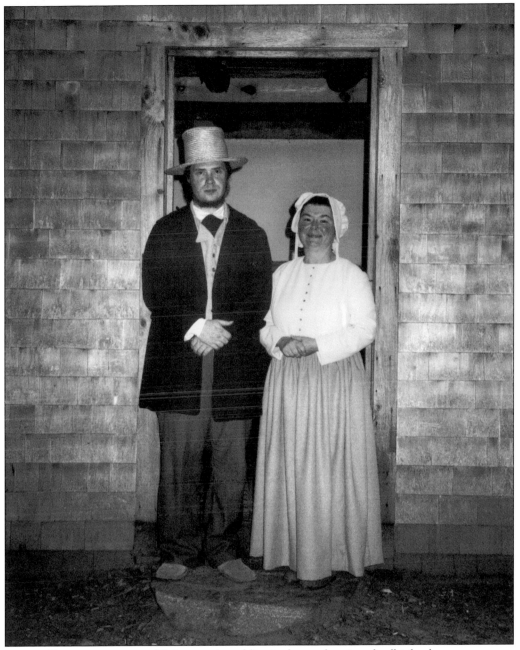

*However mean your life is, meet it and live it; do not shun it and call it hard names.*
*It is not so bad as you are. It looks poorest when you are richest.*
*The fault-finder will find faults even in paradise.*

Thoreau's mother, Cynthia, to whom he stayed close all of his life, did not altogether approve of his living in the woods. However, she did visit him there frequently, and he often walked into town to his mother's house for dinner with his family. The distance was not more than a mile and a half along the newly constructed railway line that ran close to his house and alongside the pond. Thoreau was searching for solitude, not isolation.

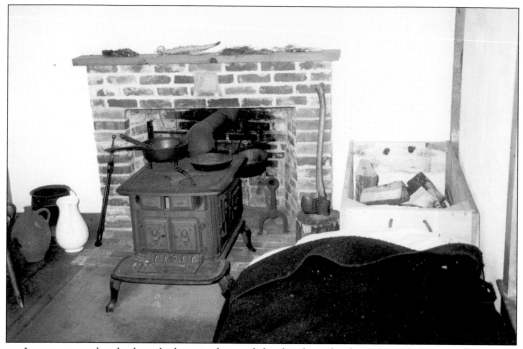

*I am no more lonely than the loon in the pond that laughs so loud, or than Walden Pond itself.*
*I am no more lonely than a single mullein or dandelion in a pasture, or a bean leaf,*
*or sorrel, or a horsefly, or a bumblebee. I am no more lonely than the Mill Brook,*
*or a weathercock, or the north star, or the south wind, or an April shower, or a January thaw,*
*or the first spider in a new house.*

This is a view of the interior of Thoreau's house, showing the simplicity in life to which he aspired. A simple bed, a wood stove, table and chairs, and a desk were all he needed to conduct his experiment in independent living. There was a woodshed behind the house, a root cellar below for storage of perishable foods, and a garret above.

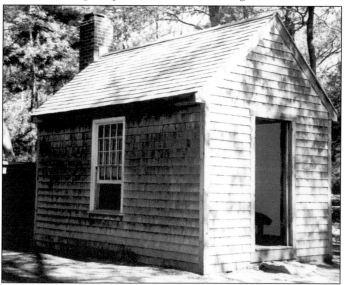

*As every season seems best to us in its turn, so the coming in of Spring is like the creation of Cosmos out of chaos and the realization of the Golden Age.*

As nature reawakens from the slumber of winter, greenery returns to surround Thoreau's house in foliage. This inspirational replica was not built at the actual site of the house because of concerns over security and maintenance. Its location makes it more accessible to more people and leaves the house site more peaceful.

*In wildness is the
preservation of the world.*

The waters of the pond are so pure
that being immersed in them seems
to be a spiritual experience of its own.
This pilgrimage to Walden, defining
reverence to many people of all different
faiths and belief patterns, is a tribute
to what Thoreau and his peers did in
understanding and teaching divinity.

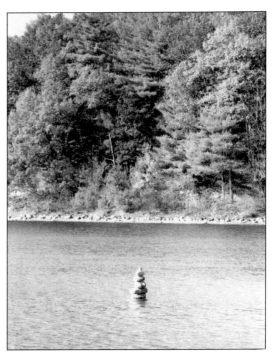

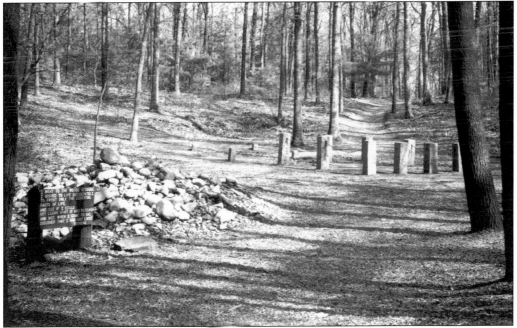

*Rather than love, than money, than fame, give me truth.*

Thoreau chose this location (on land owned by Emerson) for its tranquility, elevation, proximity to the water, and distance from his bean field. The path from his front door to the pond was well trodden. Upon his leaving in September 1847, as previously arranged, the house was sold to Emerson's gardener. It was later moved to an area known as Estabrook Woods and used as a corncrib. By 1868, it had fallen into disrepair and was dismantled.

*As a child looks forward to the coming of summer, so could we contemplate with quiet joy circle of the seasons returning without fail eternally.*

A single tree stands watch over a wintry Walden; the twilight sun cannot break through the clouds as it sets on another day. In this mystical scene, it is easy to feel the inspiration of the pond in the same way that it must have filled Thoreau with the understanding of the natural order of things.

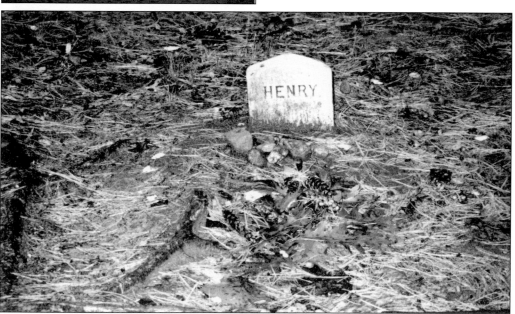

*The fact is I am a mystic, a transcendentalist, and a natural philosopher to boot.*

After his sad death at the early age of 44, Thoreau was buried originally in the Dunbar plot in Sleepy Hollow Cemetery but was later moved to Authors Ridge in another part of the grounds. His headstone says simply, "Henry." This lovely cemetery was conceived by Ralph Waldo Emerson. The quest was for it to be in keeping with nature. Today, it is another serene and tranquil place much visited by people wishing to pay their respects.

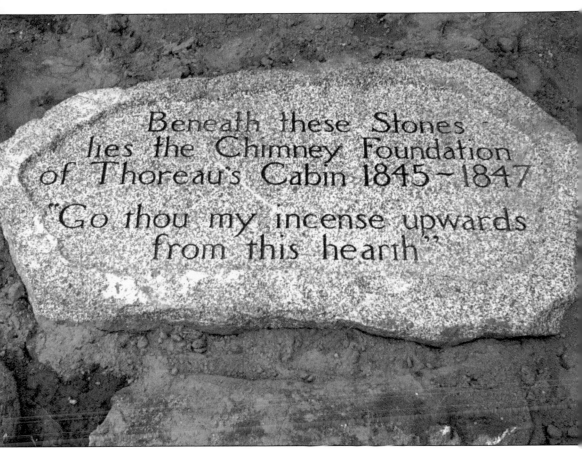

*To be serene and successful we must be at one with the universe.*

This archival photograph shows the inscription on the stone that was created to mark the location of the chimney foundation of Thoreau's house. It was placed over the foundation, after much debate, to protect it from erosion or damage. It was the discovery of this foundation that finally confirmed the location of the cabin.

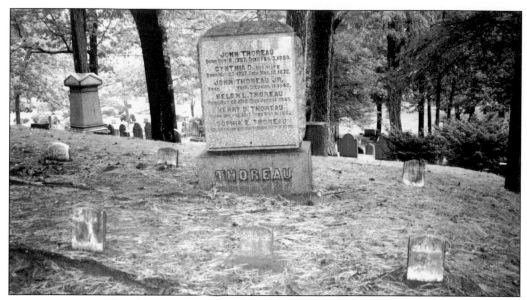

*That delicate, waving, feathery dry grass which I saw yesterday*
*is to be remembered with the autumn. The dry grasses are not dead for me.*
*A beautiful form has as much life at one season as another.*

Thoreau is in exceptionally good company on Author's Ridge. Buried alongside the Thoreau family plot are the Emersons, the Alcotts, Nathaniel Hawthorne, and many other luminaries from Concord's history. None of the Thoreau children married, and therefore, there were no descendants to continue the family name.

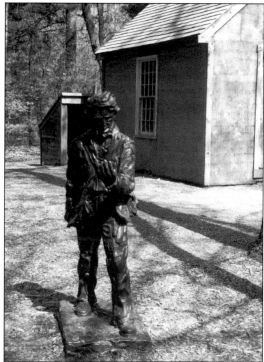

*Friends . . . will cherish each other's*
*hopes . . . are kind to each other's dreams.*

Henry David Thoreau attended the Concord Academy and, upon graduation, enrolled in Harvard University (then Harvard College), graduating in 1837. He started teaching school but was forced to resign from the public school system because of his unwillingness to administer corporal punishment. He did, however, continue teaching for a while in a private school he started in company with his elder brother John. John died in Henry's arms at the very young age of 26; he suffered a painful death of lockjaw from the infection of a finger cut while sharpening a razor.

*If a man walks in the woods
for love of them half of each day,
he is in danger of being regarded
as a loafer; but if he spends
his whole day as a speculator,
shearing off those woods and
making earth bald before her time,
he is esteemed an industrious and
enterprising citizen. As if a town
had no interest in its forests
but to cut them down!*

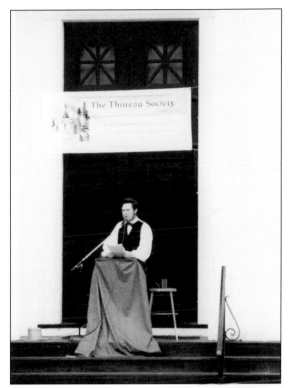

A live reading of one of Thoreau's famous political essays, *Life Without Principle*, takes place on the steps of the First Parish Church in Concord, during the Thoreau Society's Annual Gathering. Held each year around the date of Thoreau's birthday, July 12, the gathering is four days of events, lectures, seminars, and outings, allowing Thoreau lovers from all over to spend time together sharing their thoughts and philosophy in the town where Thoreau lived.

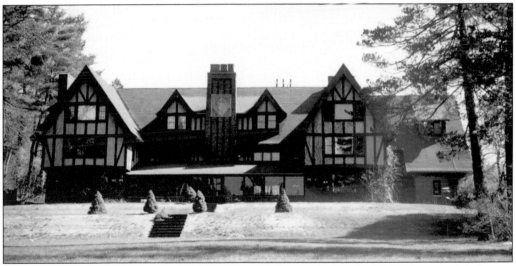

*I say, beware of all enterprises that require new clothes, and not rather a new wearer of clothes.*

This beautiful old building, about a half mile from Walden Pond, houses the offices of the Thoreau Society and the Walden Woods Project. Henry David Thoreau's name was pronounced "thorough." This fact is born out of his own writings and by those of his friends. When Nathaniel Hawthorne met Thoreau in 1842, Hawthorne wrote Thoreau's name phonetically and spelled it as "Mr. Thorow" in his journal. Bronson Alcott wrote of Thoreau in his journal entry of April 11, 1859: "He is rightly named Thorough . . . the sturdy sensibility and force in things."

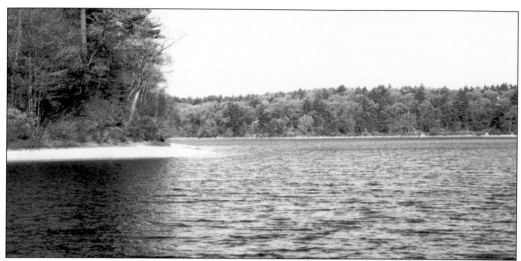

*Time is but the stream I go a-fishing in. I drink at it; but while I drink I see the sandy bottom and detect how shallow it is. Its thin current slides away, but eternity remains.*

The waters of Walden Pond are so blue that it is as if it is located in a tropical climate. Thoreau said that he "was most fortunate to have been born in such an estimable place as this," and even in these modern times, it remains a place of serenity. In the summer, the pond gives itself over to beach and water activities, but when the peace of winter descends, it again becomes a place of quietness and meditation.

*Surely joy is the condition of life.*

Thoreau was of the belief that he should be a poet of nature. He was also a scholar, speaking—with a degree of fluency—five other languages: ancient Greek, Latin, French, German, and Italian. The fall was a particularly inspirational time for him, the brilliance of the colors of the trees surrounding the pond inspiring another of his beautiful nature essays, *Autumnal Tints*.

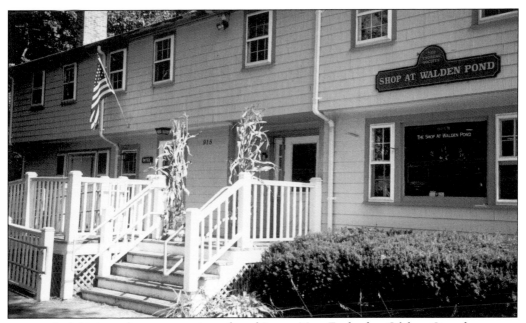

*And this is my home, my native soil; and I am a New-Englander. Of thee, O earth,
are my bones and sinew made; to thee, O sun, am I brother . . . To this dust my body will gladly
return as to its origin. Here I have my habitat. I am of thee.*

Here is the Thoreau Society Shop at Walden Pond, situated in the headquarters building of the
Walden Pond State Reservation. Open year-round, the shop serves as an information center
for the Thoreau Society and associated activities, as well as providing historical information,
visitor services for the pond area, and a large selection of books and retail items relating to
Thoreau and the Transcendental movement. The shop raises income to support the activities
of the Thoreau Society.

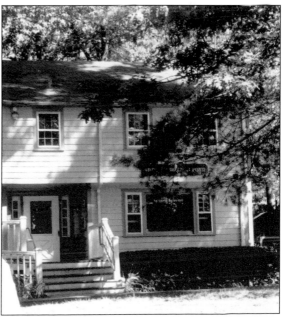

*What is the use of a house if you
haven't got a tolerable planet
to put it on?*

In *Walden,* Thoreau described his
experience while living at the pond,
where he fashioned his views of the
world. He left the pond in 1847, he
wrote, "because it seemed that I had
more lives to live, and that I could
not spare any more time for this one."
Thoreau also expressed profound
satisfaction with his life at the pond.

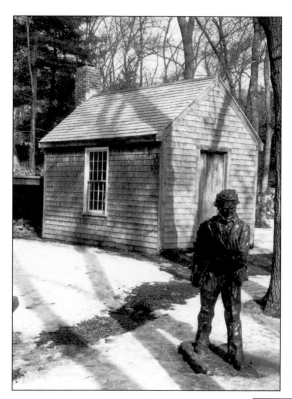

*In September or October, Walden is a perfect forest mirror, set round with stones as precious to my eye as if fewer or rarer. Nothing so fair, so pure, and at the same time so large, as a lake, perchance, lies on the surface of the earth.*

After leaving his Walden house, Thoreau moved back into Concord to spend a second period of time living in the house of his friend Emerson, who was in Europe on a lecture tour. He lived as one of the family, tutoring Emerson's children, who adored him, and assisting Emerson's wife, Lydian, with the running of the house, since he was an able craftsman. He had, in 1842, spent a short period of time living on Staten Island in New York, tutoring Emerson's brother's children, but he soon returned, citing his distaste for city life.

*Why, then, make so much ado about the Roman and the Greek, and neglect the Indian?*

Thoreau was a humanitarian, acknowledging the importance of American Indian culture and spirituality long before most white people even attempted to understand it. He tells a story about the name Walden. There was a group of Indians being rather loud on top of a hill, and the hill collapsed, forming the pond. Only one Indian woman survived, and her name was Walden. Thoreau, however, did not believe that this was the true origin of the name.

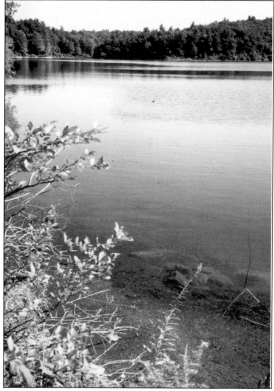

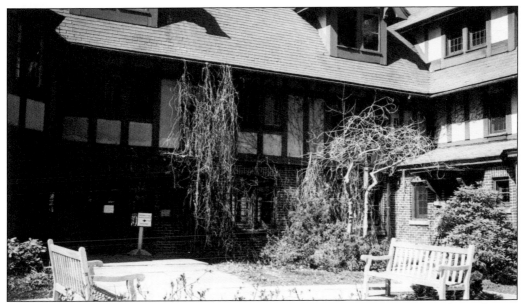

*Not till we are lost, in other words, not till we have lost the world, do we begin to find ourselves, and realize where we are and the infinite extent of our relations.*

The Thoreau Institute at Walden Woods is a tranquil building that serves as the home of the Thoreau Society and accommodates Thoreau pilgrims and visitors participating in the many projects run in association with the Walden Woods Project.

*Could a greater miracle take place than for us to look through each other's eyes for an instant.*

Here is the Henley Library, at the Thoreau Institute at Walden Woods, showing some of the many books available for perusal by visitors. The Thoreau Institute at Walden Woods is open by appointment for research and educational purposes. All of Thoreau's works are here, in many different and rare editions. After Thoreau left the pond, he turned his attention to traveling on nature excursions. The accounts of these journeys were published posthumously in *Excursions* (1863), *The Maine Woods* (1864), *Cape Cod* (1865), and *A Yankee In Canada* (1866).

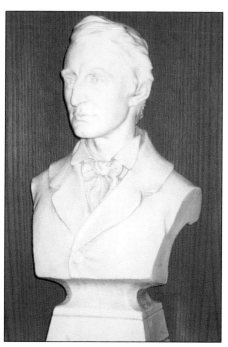

*Always you have to contend with the*
*stupidity of men. It is like a stiff soil,*
*a hard-pan. If you go deeper than usual,*
*you are sure to meet with a pan made harder*
*even by the superficial cultivation.*
*The stupid you have always with you.*

This bust of Henry David Thoreau, housed in the Henley Library of the Thoreau Institute at Walden Woods, was sculpted by Walton Ricketson, the son of Daniel Ricketson of New Bedford, a great friend of Thoreau's. Ricketson was a member of the idealist Concord group comprising Thoreau, Emerson, and the New England Transcendentalists, including luminaries such as Ellery Channing, George Ripley, Margaret Fuller, and others. The Transcendental movement was also taking root in Boston and Cambridge.

*Men are more obedient at first to words than ideas. They mind names more than things.*
*Read to them a lecture on "Education", naming that subject, and they will think that*
*they have heard something important, but call it "Transcendentalism", and they will think*
*it moonshine. Or halve your lecture, and put a psalm at the beginning and a prayer*
*at the end of it and read it from the pulpit, and they will pronounce it good without thinking.*

The sunset at Walden Pond is a most magical time. Nature's tapestry, the changing colors of the end of the day inspire artists and photographers, as well as poets, writers, and philosophers.

# LAND SURVEYING

## Of all kinds, according to the best

methods known; the necessary data sup-
plied, in order that the boundaries of
Farms may be accurately described in
Deeds; *Woods* lotted off distinctly and
according to a regular plan; *Roads* laid
out, &c., &c. Distinct and accurate Plans
of Farms furnished, with the buildings
thereon, of any size, and with a scale of feet
attached, to accompany the Farm Book, so
that the land may be laid out in a winter
evening.

Areas warranted accurate within almost
any degree of exactness, and the Variation of the Compass given,
so that the lines can be run again.     Apply to

### HENRY D. THOREAU.

*near the Depot*
*Concord Mass*

*I do not say that John or Jonathan will realize all this; but such is the character of that morrow which mere lapse of time can never make to dawn. The light which puts out our eyes is darkness to us. Only that day dawns to which we are awake. There is more day to dawn. The sun is but a morning star.*

These are the closing words of *Walden; Or, Life In The Woods*.

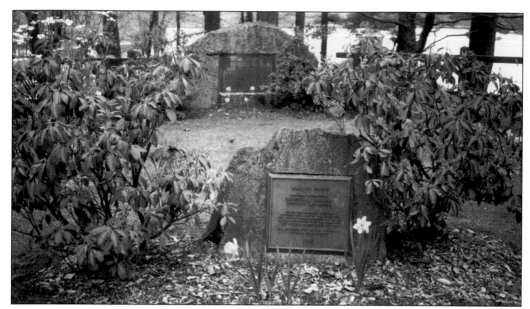

*Any man more right than his neighbor, constitutes a majority of one.*

Thoreau, like his contemporaries, was vehemently opposed to slavery. Therefore the passing of the Fugitive Slave Law in 1851 infuriated him. The law empowered the authorities to come into Thoreau's home state to repossess slaves escaping from the South. Prophetically, he wrote in his journal that he thought there would be a war over this issue.

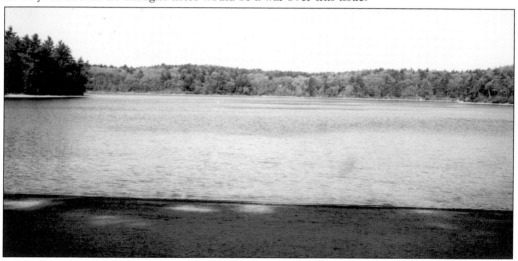

*How long we may have gazed on a particular scenery and think that we have seen and known it, when, at length, some bird or quadruped comes and takes possession of it before our eyes, and imparts to it a whole new character.*

Thoreau had assisted on the Underground Railroad since before moving to the pond; he writes that he helped an escaping slave while living there. In 1854, Anthony Burns, a slave attempting to escape to Canada, was arrested in Boston under the new act and returned to the South. Thoreau was so angry that he wrote the essay *Slavery In Massachusetts*, which was widely read and published in many abolitionist newspapers.

# *Three*

# CONCORD'S LITERARY REVOLUTION

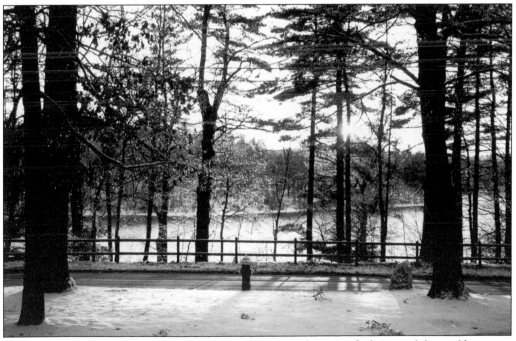

*October is the month for painted leaves. Their rich glow now flashes round the world.
As fruits and leaves and the day itself acquire a bright tint just before they fall, so the year
near its setting. October is its sunset sky; November the latest twilight.*

Here is a lovely view across the pond of the sun setting through the trees in winter. Many
observations on the changing of the seasons are included in Thoreau's *Journal*, published in
14 volumes in 1906.

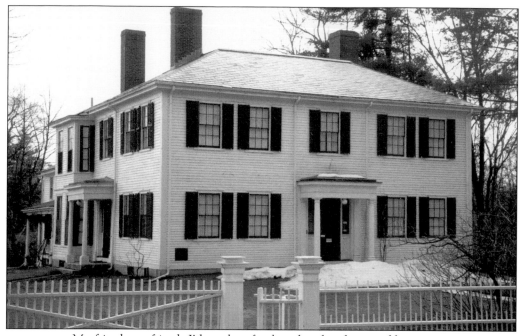

*My friend, my friend, I'd speak so frank to thee that thou wouldst pray me*
*to keep back some part, for fear I robbed myself.*

The Emerson house was purchased by Ralph Waldo Emerson in 1835, when he moved to Concord, two years before Thoreau graduated from Harvard, when Emerson gave the *Phi Beta Kappa Address (The American Scholar)*. Emerson lived here for the rest of his life with his second wife, Lydian. Thoreau lived in the house during two separate periods: one before and one after his time at Walden Pond.

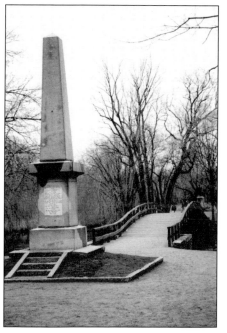

*On this green bank, by this soft stream,*
*We set today a votive stone;*
*That memory may their deed redeem,*
*When, like our sires, our sons are gone . . .*
—Ralph Waldo Emerson
From the "Concord Hymn," sung at the completion
of the Battle Monument, July 4, 1837

Emerson's influence on Thoreau was essential to his growth, as was the intensity of their friendship. The two men became spiritual allies. Emerson was older by some 14 years and, according to some, was more of a father figure to Thoreau. He was born on May 25, 1803, and died at the age of 79, on April 27, 1882.

*Conservation stands on this, that*
*a man cannot jump out of his skin;*
*and well for him that he cannot,*
*for his skin is the world; and the stars*
*of heaven do hold him there; in the*
*folly of men glitters the wisdom of God.*
—Ralph Waldo Emerson

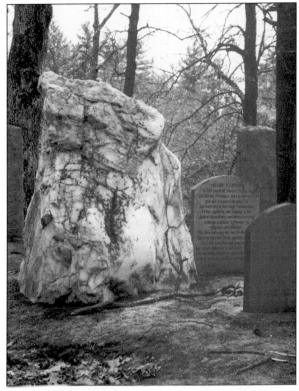

In 1835, Emerson delivered the address commemorating the 200th anniversary of the town of Concord, having become the hub of the literary movement in the town. His most groundbreaking work, published anonymously in 1836, was entitled *Nature*. In this beautiful piece, he states his belief that one could transcend the materialistic world of sensory experience and become conscious of the all-pervading spirit of the universe and that God could be best found by looking into one's own soul. This was at the heart of Transcendentalism. This huge piece of quartz marks his grave site in Sleepy Hollow Cemetery.

*A subtle chain of countless rings*
*The next unto the farthest brings,*
*The eye reads omens where it goes,*
*And speaks all languages the rose,*
*And, striving to be man, the worm*
*Mounts through all the spires of form.*

—Ralph Waldo Emerson

The Emerson family plot stands proudly in the beautifully landscaped cemetery, with Ralph Waldo Emerson at its center, sharing Author's Ridge with his literary friends. Emerson was an ordained minister in the Unitarian Church. His preaching from the pulpit won him accolades, but his dissatisfaction with the rigid doctrines of the church led him to resign from the ministry, later referring to the church as "corpse-cold Unitarianism." His essay *The Divinity School Address* (1838) was directed against what he considered to be a lifeless Christian tradition.

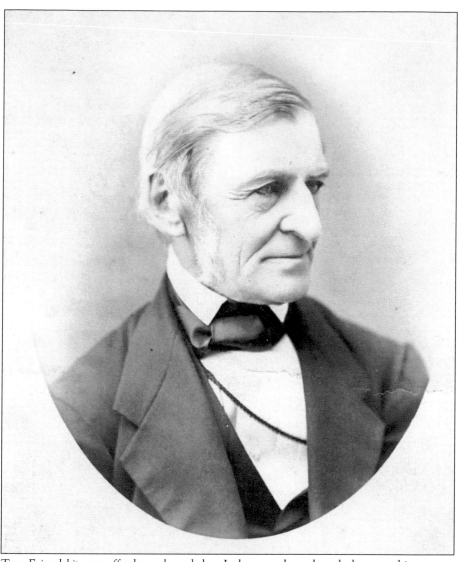

*True Friendship can afford true knowledge. It does not depend on darkness and ignorance.
A want of discernment cannot be an ingredient in it. If I can see my Friend's virtues
more distinctly than another's, his faults too are made more conspicuous by contrast.*

Emerson, a man of huge intellect and compassionate brilliance, remained a staunch ally of Thoreau and was responsible for nurturing him and gently pushing him in the direction necessary to achieve his goals. Thoreau's friendship with Emerson, given Emerson's stature both locally and nationally—his famous essay *Self Reliance* made his name internationally known—helped Thoreau's reputation greatly.

*The morning wind forever blows,*
*the poem of creation is uninterrupted;*
*but few are the ears that hear it.*
*Olympus is but the outside*
*of the earth everywhere.*

Thoreau was a fervent supporter of
John Brown, the antislavery activist, and
wrote the emotional essay *A Plea For
Captain John Brown* (1860), in which
he pleaded with the government not to
execute Brown—to no avail as it turned
out. This essay was first read to the people
of Concord on October 30, 1859.

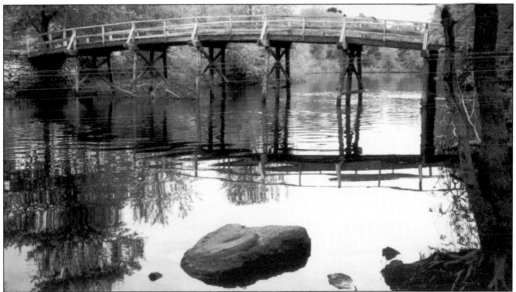

*By the rude bridge that arched the flood,*
*Their flag to April's breeze unfurled,*
*Here once the embattled farmers stood,*
*And fired the shot heard 'round the world.*

—Ralph Waldo Emerson
From the "Concord Hymn"

The Old North Bridge in Concord is the site of the beginning of the Revolutionary War,
April 19, 1775. The monument, designed by Daniel Chester French, was dedicated on
April 19, 1875, and inscribed with these immortal words by Emerson. The minutemen here
fired this shot, and two British soldiers died, thereby igniting the war.

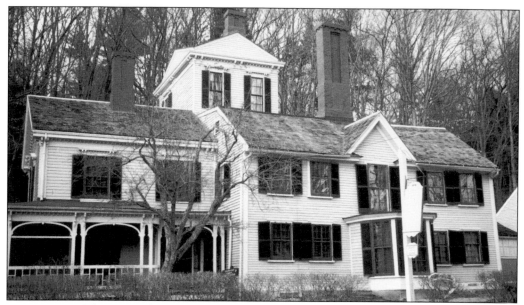

*The very timber and boards and shingles of which our houses are made
grew but yesterday in a wilderness where the Indian still hunts and the moose runs wild.*

The Wayside, home of Nathaniel Hawthorne and his wife, Sophia, is another of Concord's well-known houses. Hawthorne, the descendant of the presiding judge at the Salem witch trials of 1693, removed the first "e" from his last name (Hawethorne) to distance himself from that infamous event in New England's history.

*I love to look at Ebby Hubbard's oaks and pines on the hillside from Brister's Hill.
Am thankful that there is one old miser who will not sell or cut his woods,
though it is said that they are wasting. It is an ill wind that blows nobody any good.*

Nathaniel Hawthorne, a good friend of Emerson and Thoreau, was a key member of this group of radical writers. Often he could be found walking in Walden Woods and in areas such as Brister's Hill with his friend Emerson.

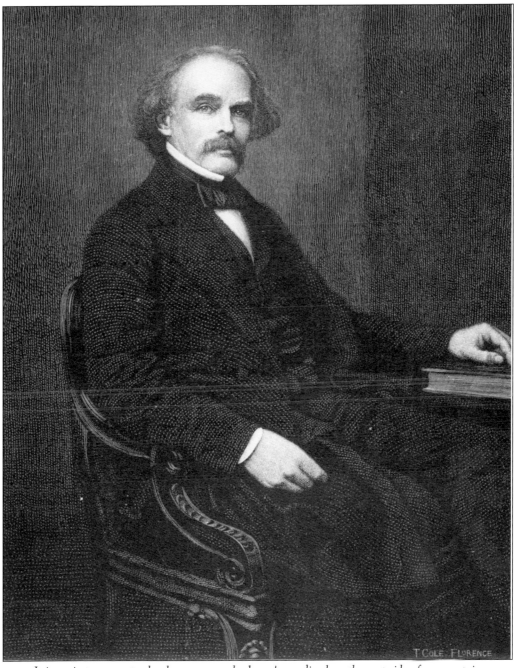

*It is an important epoch when a man who has always lived on the east side of a mountain and seen it in the west, travels round and sees it in the east. Yet the universe is a sphere whose centre is wherever there is intelligence. The sun is not so central as a man.*

Here is an archival image of Nathaniel Hawthorne, another fascinating character in the group of authors living in Concord at the time of the birth of Transcendentalism. Hawthorne is the esteemed author of *The Scarlet Letter* (1850) and *Mosses From An Old Manse* (1846), which was inspired by his time living at the Old Manse, yet another famous house in Concord.

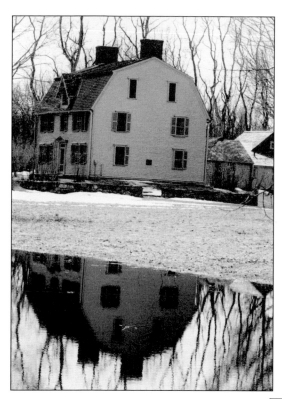

*The modern Christian is a man who has consented to say all the prayers in the liturgy, provided you will let him go straight to bed and sleep quietly afterward.*

The Old Manse was the home of William Emerson, the clerical minister of the town at the time of the "shot heard 'round the world." In fact, he could see the start of the battle at the North Bridge from his window. He was the grandfather of Ralph Waldo Emerson, who lived in this house upon moving to Concord in 1834.

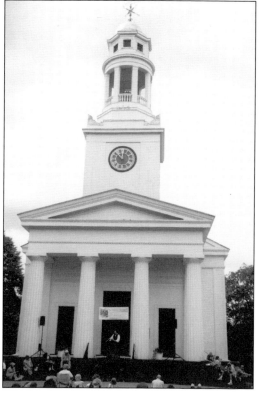

*A town is saved, not more by the righteous men in it than by the woods and swamps that surround it.*

Concord's First Parish Church, which was rebuilt after a fire in 1900 or 1901, was used as a meeting place for the minutemen on April 19, 1775, and as the site of many lectures during the writers' era in the first half on the 19th century. Once a year during the Thoreau Society's Annual Gathering, the spirit of Thoreau comes alive as the church serves as a backdrop for a reading of one of his essays.

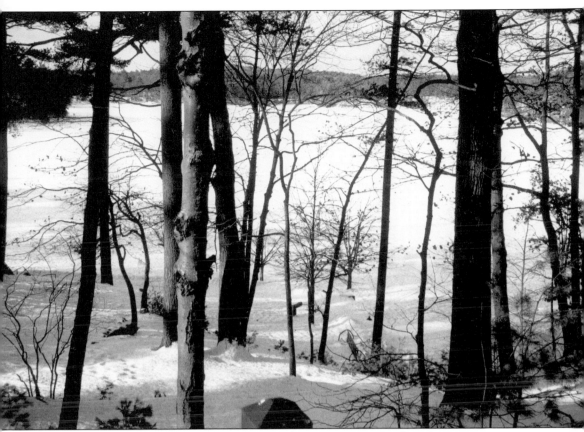

*The country knows not yet, or in the least part, how great a son it has lost. It seems an injury*
*that he should leave in the midst his broken task, which none else can finish,—a kind of*
*indignity to so noble a soul, that it should depart out of nature before yet he has been*
*really shown to his peers for what he is. But he, at least, is content. His soul was made*
*for the noblest society; he had in a short life exhausted the capabilities of this world;*
*wherever there is knowledge, wherever there is virtue, wherever there is beauty,*
*he will find a home.*

—Ralph Waldo Emerson

Ralph Waldo Emerson delivered his beautiful and moving eulogy to Henry David Thoreau on
May 11, 1862.

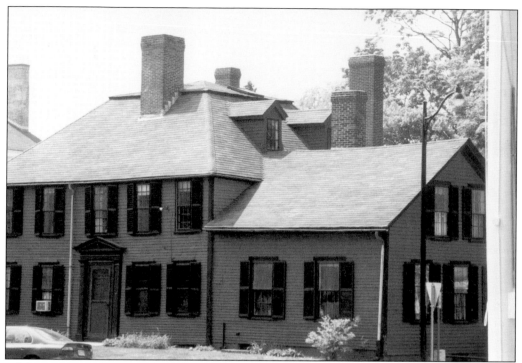

*Most men, it appears to me, do not care for Nature, and would sell their share in all her beauty, for as long as they may live, for a stated and not very large sum. Thank God they cannot yet fly and lay waste the sky as well as the earth. We are safe on that side for the present. It is for the very reason that some do not care for these things that we need to combine to protect all from the vandalism of a few.*

Wright's Tavern in Concord center is best known for its having been taken over by British soldiers on April 19, 1775. Earlier that day, it had been used as a muster point for the minutemen when they arrived in the town that morning, after an initial skirmish in Lexington.

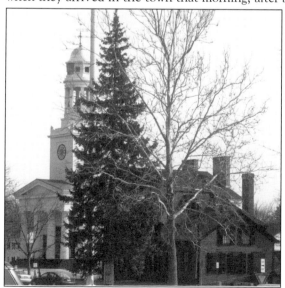

*There are a thousand hacking at the branches of evil to one who is striking at the root.*

The inspirational spire of the First Parish Church rises above Wright's Tavern in this historical view of Concord center. Among Concord's 2000 habitants in the 1840s, were women transcendentalists Margaret Fuller, the first editor of the *Dial*, the magazine of the group, and Elizabeth Peabody, who came to join the movement and exchange views with Emerson.

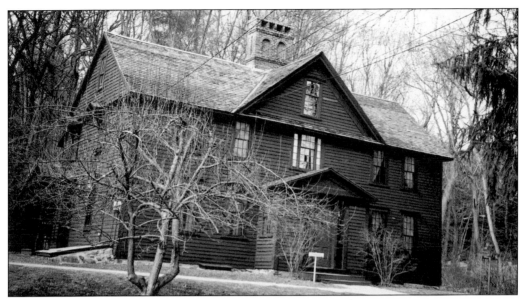

*It is never too late to give up our prejudices.*

Bronson Alcott and his family moved to the Orchard House (above) after attempting to found a Transcendental commune called Fruitlands. The venture was not a success, and when the Alcotts moved to Concord, they were not well received due to their financial insecurity. In the face of local opinion, however, Emerson and Thoreau befriended Alcott; Thoreau considered Bronson Alcott "the sanest man alive."

*The greater part of what my neighbors call good I believe in my soul to be bad, and if I repent of any thing, it is very likely to be my good behavior. What demon possessed me that I behaved so well?*

This is Bronson Alcott's School of Philosophy on the grounds of Orchard House. The Alcotts had four talented and clever young daughters, the second eldest of whom, Louisa, became famous for her book *Little Women,* based her family's life at Orchard House or "Apple Slump." The girls would often visit Thoreau at Walden Pond and bring him nice things to eat.

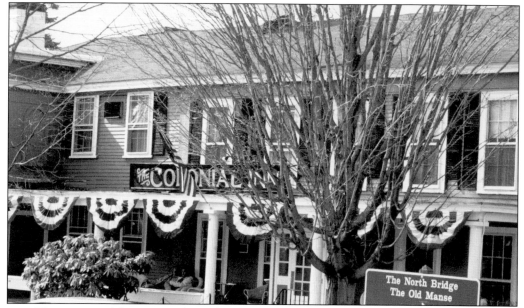

*The prospect of the young is forward and unbounded, mingling the future with the present.*

Situated in Monument Square in the center of Concord, the Colonial Inn is the most famous lodging house in Concord. The section to the right of the main building was owned by two of Thoreau's aunts at the time of his going to jail in 1846, and it was one of these aunts who paid his taxes so he was released after one night.

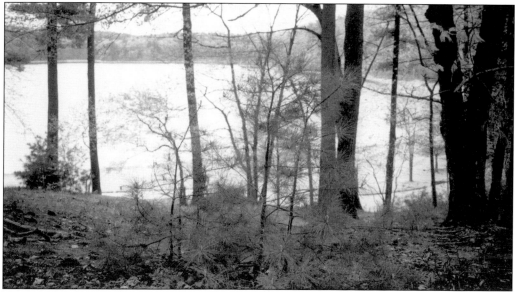

*If some are prosecuted for abusing children, others deserve to be prosecuted for maltreating the face of nature committed to their care.*

Emerson said, "Mr. Thoreau dedicated his genius with such entire love to the fields, hills and waters of his native town, that he made them known and interesting to all reading Americans, and to people over the sea."

# *Four*

# THOREAU'S WALDEN

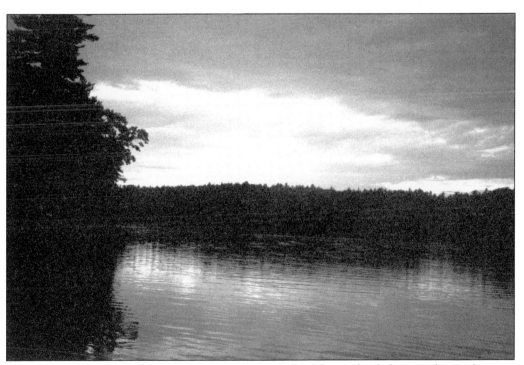

*When I wrote the following pages, or rather the bulk of them, I lived alone, in the woods,*
*a mile from any neighbor, in a house which I had built myself, on the shore of Walden Pond,*
*in Concord, Massachusetts, and earned my living by the labor of my hands only.*

—*Walden*

No doubt, Thoreau would be astonished by the attention his book and the sojourn that inspired it have received. It surely would surprise him to see a replica of his "tight shingled and plastered" house visited by so many people. A famous drawing by his sister Sophia (used also by the Thoreau Society as its logo) was one of the models for the construction.

61

*So we saunter toward the Holy Land, till one day the sun shall shine more brightly than ever he has done, shall perchance shine into our minds and hearts, and light up our whole lives with a great awakening light, as warm and serene and golden as on a bank side in autumn.*

Thoreau's Walden Bed and Breakfast, a private house whose land borders the Walden Pond State Reservation and provides a wonderful opportunity to enjoy an overnight stay, is the only accommodation available at Walden Pond.

*All Walden Woods might have been preserved for our park forever, with Walden in its midst.*

Walden (1854) may have been Thoreau's definitive work on humankind's relationship to the environment, but he wrote many beautiful natural history essays on the subject including *Natural History Of Massachusetts* (1842), *A Walk To Wachusett* and *A Winter Walk* (1843), *The Succession Of Forest Trees* (1860), and *Walking* (1862).

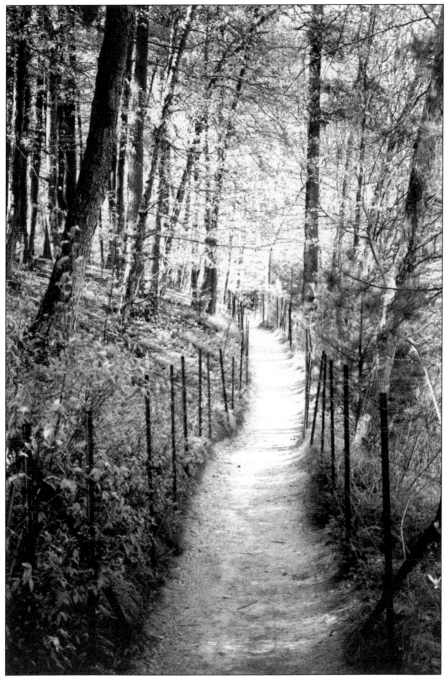

*In all my rambles I have seen no landscape which can make me forget Fair Haven. I still sit on its Cliff in a new spring day & look over the awakening woods & the river & hear the new birds sing with the same delight as ever—It is as sweet a mystery to me as ever what this world is—*

Walden's intrinsic value is its symbolic meaning to so many people, and Thoreau's writings on the natural world have even more meaning today in a world trying to cope with mass destruction of the land.

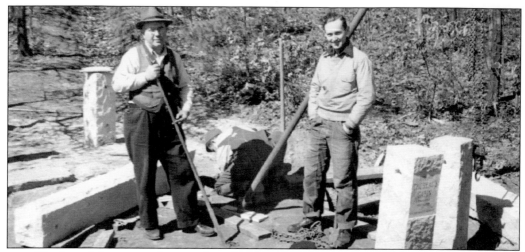

*The fate of the country does not depend on how you vote at the polls—the worst man is as strong as the best at that game; it does not depend on what kind of paper you drop in the ballot-box once a year, but on what kind of man you drop from your chamber into the street every morning.*

Roland Wells Robbins (right) is pictured c. 1945 during his search for, and excavation of, Thoreau's house site at Walden Pond; Ray Harris is with him. The pond itself is the central symbol in *Walden*, it is as an eye looking up to heaven and, because an eye, an entrance into the very mind of nature. (Photograph by Roland Wells Robbins.)

*I thrive best on solitude. If I have had a companion only one day in a week, unless it were one or two I could name, I find that the value of the week to me has been seriously affected. It dissipates my days, and often it takes me another week to get over it.*

For more than a century and a half, people have been making pilgrimages to Walden Woods. They come in search of meaning and understanding—the perennial search for spirituality. Thoreau created a whole new way to pursue this quest by spending time in quiet reflection and communion with nature.

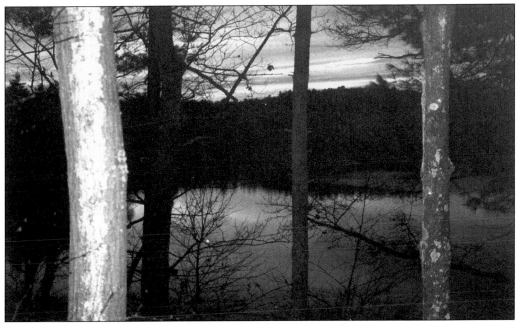

*Walden Woods was my forest walk.*

—*Journal*, April 12, 1852

*The ocean is but a larger lake.*

—*Walden*

After he left the pond, Thoreau commenced making excursions into nature farther afield than ever before. He traveled to the Maine woods in 1846 (while still living at the pond), and in 1853, (*Ktaadn and the Maine Woods* 1848), then to Cape Cod in 1849, 1850 and 1855, (*Cape Cod* 1855), and to Quebec, Canada in 1850, (*A Yankee In Canada* 1853). He also traveled to the White Mountains of New Hampshire in 1858, where he climbed Mount Washington, and he made a trip to Minnesota with his friend Horace Mann Jr. in 1861, in an attempt to regain his failing health.

*But this hunting of the moose merely for the satisfaction of killing him—not even for the sake of his hide—without making any extraordinary exertion or running any risk yourself, is too much like going out by night to some wood-side pasture and shooting your neighbor's horses.*

Thoreau never married, in fact none of the four Thoreau children ever married and, therefore, there were no descendants. His elder brother John died in 1842 of lockjaw, his elder sister Helen died in 1849, apparently of tuberculosis, and his father John died in 1859. Thoreau was outlived only by his sister Sophia and his mother, Cynthia.

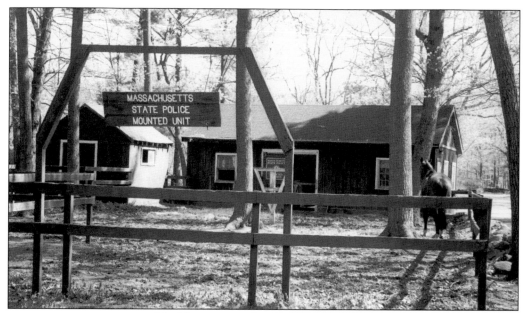

*The Universe is wider than our views of it.*

The Massachusetts State Police maintain a mounted unit on the Walden Pond State Reservation. This is an effective way to patrol the woods.

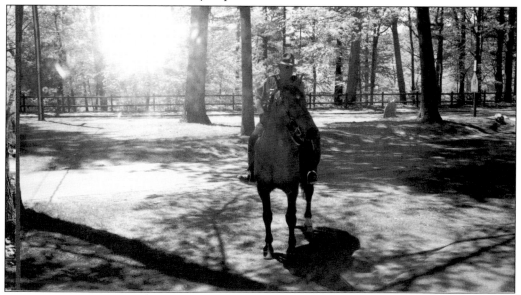

*I have not read far in the statutes of this Commonwealth. It is not profitable reading.*
*They do not always say what is true; and they do not always mean what they say.*

Thoreau's other major writings were his renowned political essays, the best known of which is *Civil Disobedience*, or *Resistance To Civil Government* (1849). This essay influenced great leaders such as Mohandas Gandhi, Dr. Martin Luther King Jr., John F. Kennedy, and Leo Tolstoy. His other political essays include *Slavery In Massachusetts* (1854), *A Plea For Captain John Brown* (1860), and *Life Without Principle* (1863).

*I have never got over my surprise
that I should have been born into
the most estimable place in all the world,
and in the nick of time, too.*

This is a view of Walden Woods at peace under a blanket of snow. Thoreau, poet and naturalist, was foremost a self-described Transcendentalist. *Walden* is a Transcendental book; the text is meant to make the reader take a deeper look through the surface of nature and discover the unity within.

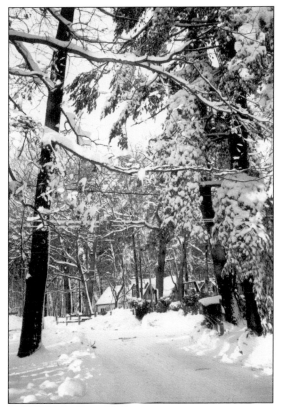

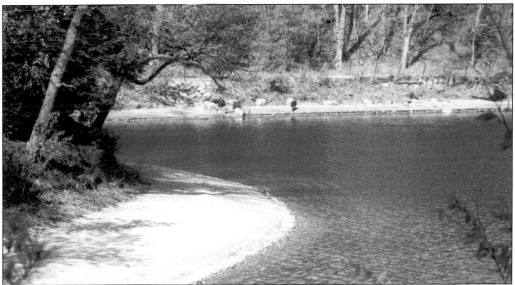

*A man is rich in proportion to the number of things he can afford to let alone.*

Walden Pond is a haven for pilgrims seeking solitude and peace. Thoreau showed how one can experience the serenity of the pond by simply being there. He claimed to have first seen the pond in 1822, at the age of five. "That woodland vision for a long time made drapery of my dreams," he said.

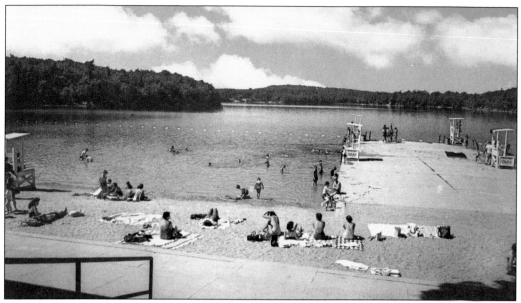

*There is no more fatal blunderer than he who consumes the greater part of his life getting his living.*

This was the excursion park that was built on the shore of Walden Pond by the Boston & Maine Railroad, allowing people from the city to visit the pond via the railway. It featured a beach and a safe place to swim. It did, inevitably, tremendous damage to the environment and, after many years of use, burned down in 1902. It was never rebuilt.

*I heartily accept the motto,—"That government is best which governs least;" and I should like to see it acted up to more rapidly and systematically. Carried out, it finally amounts to this, which also I believe,—"That government is best which governs not at all;" and when men are prepared for it, that will be the kind of government which they will have.*

Here is a vintage photograph of Old Marlborough Road, today a lovely residential area adjacent to Walden Woods, another favorite walking place of Emerson and Thoreau.

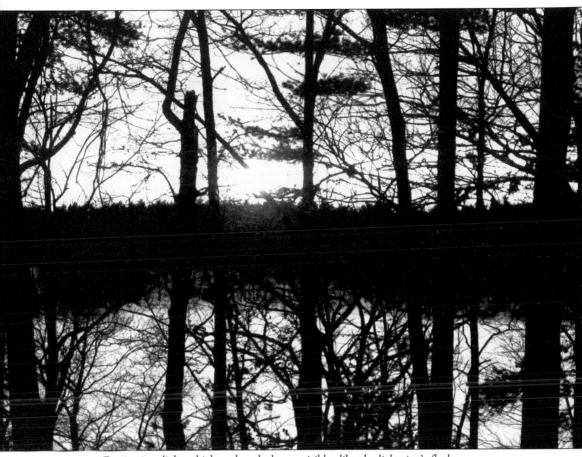

*Genius is a light which makes darkness visible, like the lightning's flash,*
*which perchance shatters the temple of knowledge itself,—and not a taper lighted*
*at the hearth-stone of the race, which pales before the light of common day.*

The sun sets on another tranquil day at Walden Pond. A fascinating and little known fact is that Thoreau's two-year stay at Walden Pond was not the first time he had lived in nature. In the summer of 1837, he spent six weeks living with a friend in a shack on the shores of Flint's Pond (now called Sandy Pond), another pond in Walden Woods.

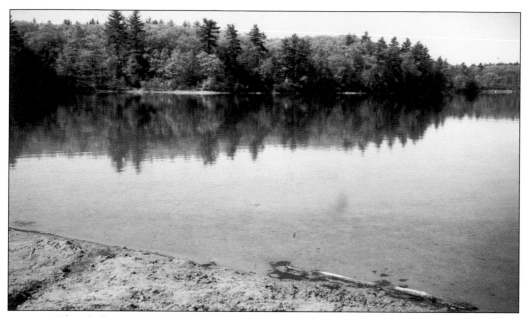

*What shall we make of the fact that you have only to stand on your head a moment to be enchanted with the beauty of the landscape?*

When the Walden Woods Project was founded in the spring of 1990 by Don Henley, about 60 percent of the area was protected from development. However, there were two separate tracts of land totaling some 43 acres, that were endangered by developers seeking to build a condominium complex on Bear Garden Hill—an area much loved and written about by Thoreau—and an extensive office park on Brister's Hill. This would have destroyed a primary site where Thoreau studied and established his principles of forest succession.

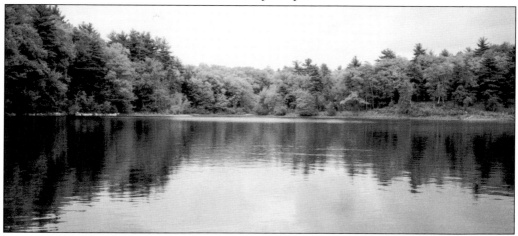

*Such is beauty ever . . . neither here nor there, now nor then . . . neither in Rome nor in Athens, but wherever there is a soul to admire.*

The sky and the trees are reflected in the waters of the pond, giving an unequaled view of nature in all its sublime glory. Today, the integrity of Walden Woods remains largely intact. This is due in large part to the efforts of the Walden Woods Project and other related conservation organizations.

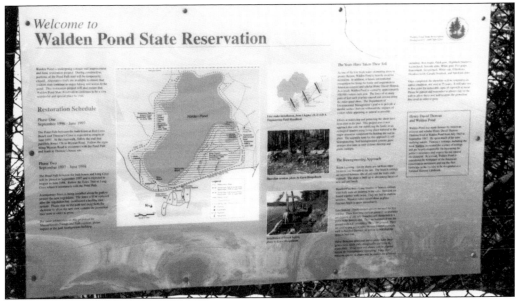

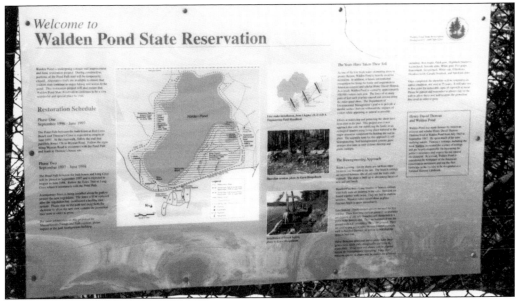

*Man is but the place where I stand, and the prospect hence is infinite. It is not a chamber of mirrors which reflect me. When I reflect, I find that there is other than me.*

While retaining the importance of Walden Pond State Reservation as an environmentally protected area, staff members provide educational programs and living history lectures for visitors. There are no commercial enterprises at the pond, another fact that helps to maintain the conservation of this complex ecosystem.

*Spring is brown; summer, green; autumn, yellow; winter, white; November, gray.*

In the dead of winter (in most years past), Walden freezes over completely, with ice thick enough to allow ice fishing and skating. Thoreau, himself, was an accomplished skater, and there is much written about this activity, which he shared with his friends, especially Emerson. They often skated on the Concord River.

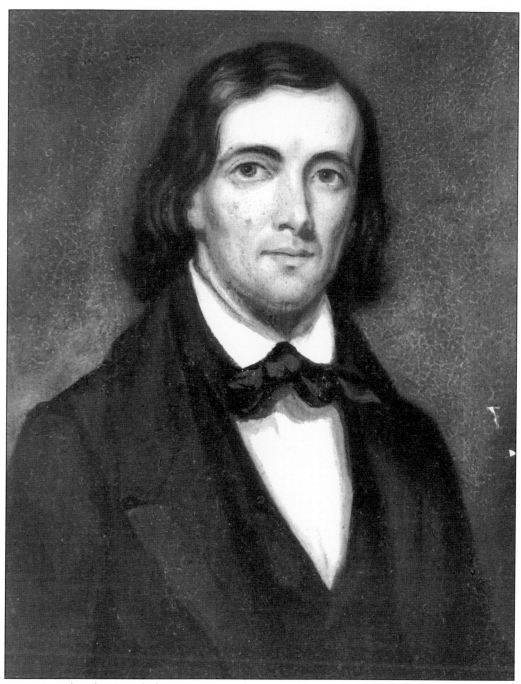

*I confess that I am lacking a sense, perchance, in this respect, and I derive no pleasure from talking with a young woman half an hour simply because she has regular features.*

Ellery Channing, a close friend and sometime biographer of Thoreau, went walking in Walden Woods one day with Thoreau, and despairing of finding a way to help him get going with his writing, decided to talk to Emerson. The result was that Emerson offered his land to Thoreau to build his house on, so as to give him a quiet place to study and write.

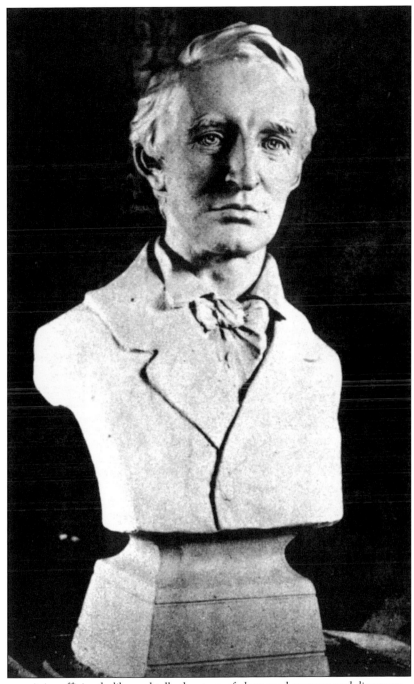

*. . . it is sufficiently like and tells the story of clear-eyed courage and directness,
a suggestion of Nature's ruggedness with Nature's refinement and wholesomeness,
and a hint too of the tenderness and faith that make him a poet as well as a naturalist.
It is a happy face as it should be.*

—Walton Ricketson

These words about Thoreau are by the sculptor Walton Ricketson.

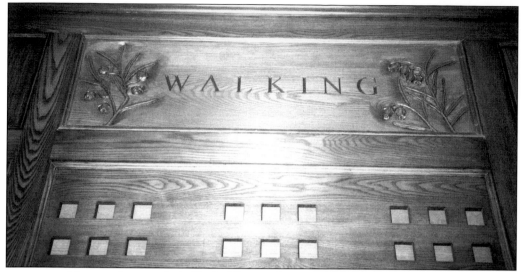

*How much more admirable the Bhagvat-Geeta than all the ruins of the East!*

Here is one of the many panels in the Henley Library at the Thoreau Institute at Walden Woods; this one commemorates Thoreau's classic nature essay, *Walking* (1862). Beautifully carved, these panels evoke the legacy of Thoreau. In describing his life at Walden Pond, Thoreau sees himself as a transcendental "seer" in the making, while discovering the deeper meaning in the landscape.

*Think how much the eyes of painters of all kinds, and of manufacturers of cloth and paper, and paper-stainers, and countless others, are to be educated by these autumnal colors. The stationer's envelopes may be of various tints, yet not so various as those of the leaves of a single tree.*

In Walden, Thoreau says, "I borrowed an ax . . . ," and commenced building his house. There were likely more reasons for doing this than he mentions in the text. Even though he loved to read in Emerson's extensive library, he needed a place of solitude to write. His own home did not allow any quiet time for meditation because there was no privacy.

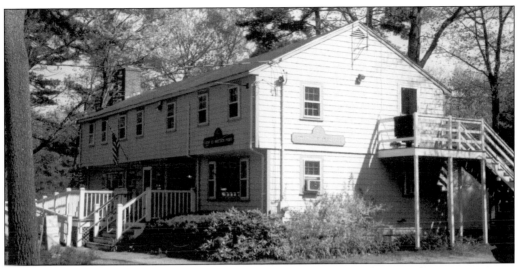

*I have always been regretting that I was not as wise as the day I was born.*

Aside from the house replica, the park headquarters is the only building on the Walden Pond State Reservation. It houses the offices of the Massachusetts Department of Environmental Management, the Shop at Walden Pond, and the Tsongas Gallery, used for exhibitions of art and photography. While Thoreau lived at the pond, he remained busy with his writing projects; besides writing the full draft of *A Week On The Concord And Merrimack Rivers*, he wrote (and read at the Concord Lyceum) a lecture on the Scottish philosopher Thomas Carlyle and began work on *Walden*.

*Hope and the future for me are not in lawns and cultivated fields, not in towns and cities, but in the impervious and quaking swamps.*

When Thoreau's first book, *A Week On The Concord And Merrimack Rivers*, was published, it was not an immediate success. He had to make a deal with the publishers that he would buy any unsold copies in order to get the book published. Of the first run of 1,000 copies, he was obliged to buy 700, which he stored in his family's attic. Thoreau commented that he now had a fine library of some 900 books, 700 of which he had written himself.

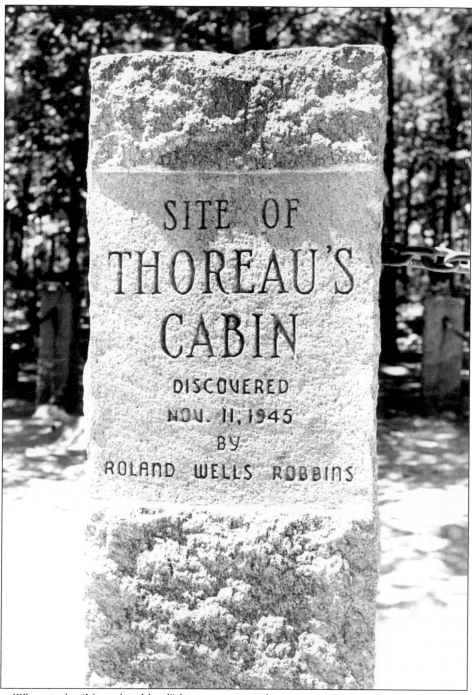

*Where is the "Unexplored land" but in our untried enterprises? To an adventurous spirit any place . . . or his own yard is "unexplored land" . . .*

Henry David Thoreau was sometimes thought by his peers to be prickly and antisocial. In his writings, however, he was a man anyone would wish to have as a friend. He is still, to many people, that friend, and spiritual adviser, someone who dealt only with the truth.

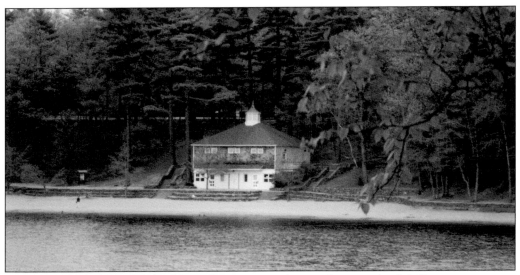

*This little symbol that Nature has transmitted to us, this arrow-headed character
is probably more ancient than any other, and to my mind it has not been deciphered.*

Thoreau understood and greatly respected the cultures of American Indians, appreciating their nurturing of the land in everything that they did. He had an amazing eye and was able to notice immense detail in the natural world. During his endless walking, he found a vast number of Indian arrowheads, to which he refers in the above journal entry on the subject.

*To affect the quality of the day, that is the highest of arts.*

Animals feature prominently in *Walden*. In the chapter "Brute Neighbors," Thoreau writes, "many animals carry some portion of our thoughts." A personal favorite of his appears to be the loon. This bird could be the animal representative of Thoreau himself, a pond dweller, a little mysterious and strange.

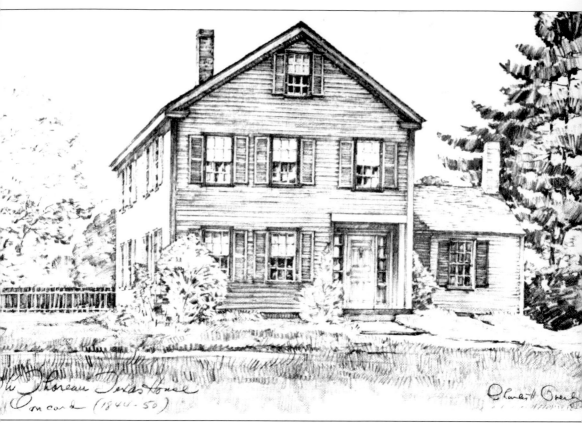

*Cast your whole vote, not a strip of paper merely.*

This is a drawing of the "Thoreau Texas House," which was actually built by Thoreau and his father. It was located near the railroad station in an area known as Texas because of the cattle shows held there and was destroyed by a hurricane in the 1930s. After six years, the family moved to the "Yellow House," where Thoreau died in his sister Sophia's arms in 1862. This house is still a private residence and still yellow. His mother, Cynthia, took in boarders in this house, as she did in all the family's various homes in Concord. (Drawing by Charles Overly.)

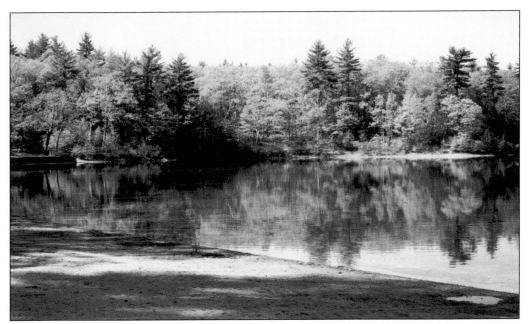

*A thing is right when it protects and enhances "the integrity, stability, and beauty" of the ecosystem. It is wrong when it tends otherwise.*

—Aldo Leopold

A renowned 20th-century environmental writer, Aldo Leopold echoed the thoughts of Thoreau. It is this undisputed understanding of his message that has made Thoreau so influential to the writers who have followed him. Although Emerson's famous essay *Nature* came first, Thoreau is generally considered to be the father of American conservation.

*I know this well, that if one thousand, if one hundred, if ten men whom I could name,—if ten honest men only,—aye, if one HONEST man, in this State of Massachusetts, ceasing to hold slaves, were actually to withdraw from this copartnership, and be locked up in the county jail therefor, it would be the abolition of slavery in America. For it matters not how small the beginning may seem to be; what is once well done is done for ever.*

—*Civil Disobedience*

This archival image shows the Concord jail where Thoreau spent a night in July 1846 for refusing to pay his taxes. The building is now gone, but the site is marked with a bronze plaque.

79

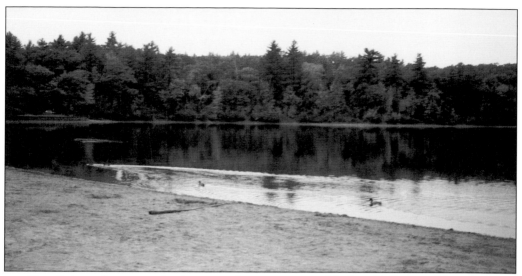

*How fitting to have every day in a vase of water on your table the wild-flowers of the season which are just blossoming!*

Thoreau's total passion for Walden Pond is perhaps best described by the pond itself, the solitude that was so essential to his philosophy is evident in this peaceful image. Part one of *Walden* includes the chapters "Economy" and "Where I Lived and What I Lived For." "Economy" is a small book in itself, including all the ideas that Thoreau expands upon in the rest of the book.

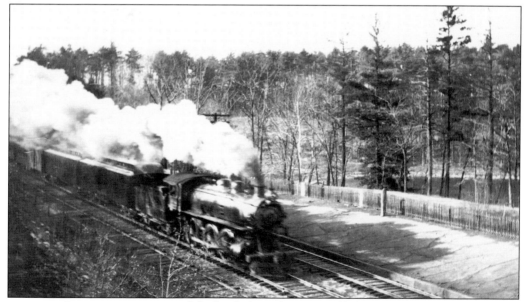

*I cannot spare my moonlight for the best of man I am likely to get in exchange.*

A steam locomotive charges past Walden Pond. Thoreau saw the railroad as representing excessive complication and destructive materialism. Its opening did, however, allow Emerson and others to live in Concord and travel quickly to Boston to lecture and socialize. (Photograph by Norman Foerster.)

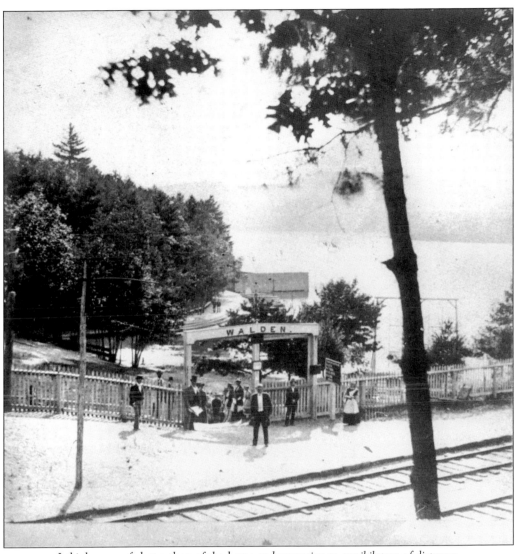

*I think more of skates than of the horse or locomotive as annihilators of distance,*
*for while I am getting along with the speed of the horse, I have at the same time*
*the satisfaction of the horse and his rider, and far more adventure*
*and variety than if I were riding.*

Here is the railroad stop at Walden Pond, showing the entrance to the excursion park that was so popular with people from the city. Thoreau's house had been not more than a couple of hundred yards from this beach area.

*When one tugs on a single thing in nature, one finds it attached to the rest of the world.*
—John Muir

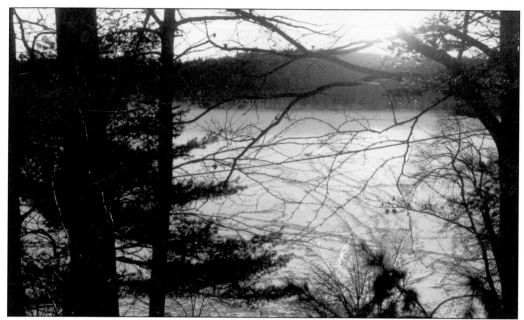

*He who looks over a lake at noon, when the waves run, little imagines its serene and placid beauty at evening, as little as he anticipates his own serenity.*

Here is a view of Walden Woods, the beloved area of Thoreau's nature walks. This activity is eloquently described in the essay *Walking,* in which Thoreau pleads for conservation of the earth's wild places. This beautiful work is today accepted as a pioneer work in the conservation and national park movements in America.

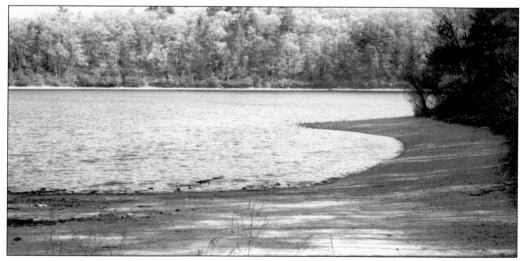

*The mass of men lead lives of quiet desperation.*

One of Thoreau's myriad accomplishments was having revolutionized the pencil-making business that was his father John's occupation. He did not spend much time in the family business, but in his usual curious manner, he devised a new method for inserting the lead into the pencil. He then quit, stating, "that I have now made the perfect pencil, so why make any more!"

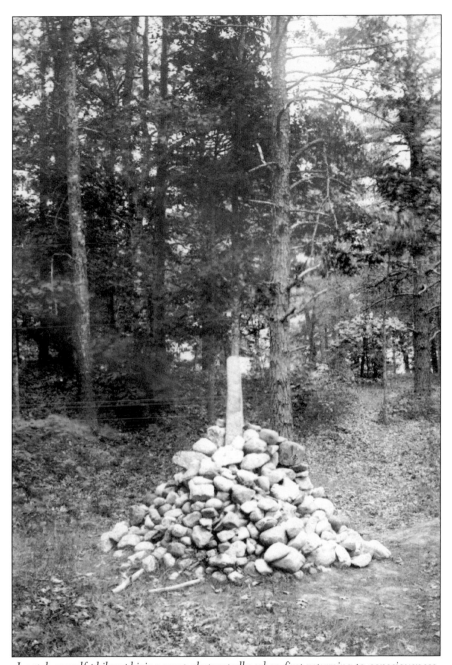

*I catch myself philosophizing most abstractedly when first returning to consciousness
in the night or morning. I make the truest observations and distinctions then,
when the will is yet wholly asleep and the mind works like a machine without friction.*

Thoreau's use of language was outstanding. Being a voracious reader and fluent in ancient languages, he was able to convey a truly cutting message in words of beauty. He described the natural world with vitality and enthusiasm in the manner of the classical Greek lyric poets and digressed to produce his pithy and poetic pronouncements, or what Emerson called Thoreau's "witty wisdom."

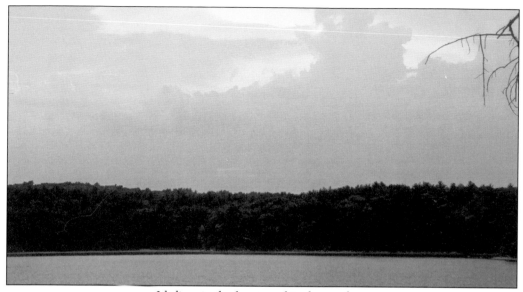

*I believe in the forest, and in the meadow,*
*and in the night in which the corn grows.*

Thoreau would walk perhaps 30 miles in a day, carrying a pencil and paper, some string, a spyglass, a magnifying glass, and his flute. His walking stick was notched for measuring the length of plants and trees that he encountered. He recorded in great detail everything in these woods. Thoreau thought people could live without the trappings of materialism and should spend more time doing things that pleased them.

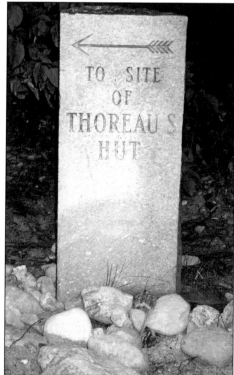

*If I am not I, who will be?*

Here is the stone marker showing the way to Thoreau's house site. It is almost a spiritual pilgrimage, such as journeying to Mecca, for countless people who come to the pond to experience the land of Thoreau and Emerson. Perhaps many do not know why they are drawn to this magical place but feel compelled nonetheless.

*I had prepared myself to speak a word
now for Nature—for absolute Freedom
and wildness, as contrasted with
a freedom and culture simply civil—
to regard man as an inhabitant,
or a part and parcel of nature—
rather than a member of society.*

Today countless people come to
enjoy the lovely beach and clear calm
waters of Walden Pond. It remains
a place of tranquility even on these
busy summer days, as it is possible to
find any number of quiet places.

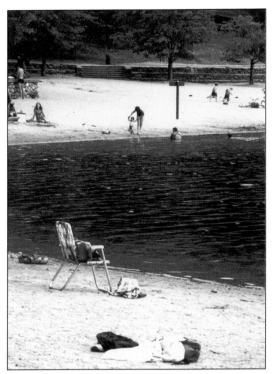

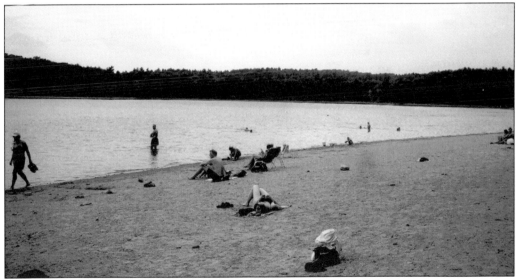

*In the society of many men, or in the midst of what is called success,
I find my life of no account, and my spirits rapidly fail . . . But when I hear only
a rustling oak leaf, or the faint metallic cheep of a tree sparrow, for variety
in my winter walk, my life becomes content and sweet as the kernel of a nut.*

Walter Harding, one of the founders of the Thoreau Society in 1941 and esteemed Thoreau scholar, said this in his forward to *Walden, An Annotated Edition*: "It is true our success may be only momentary, but it is worth the effort; for in those moments we achieve a higher plane of life."

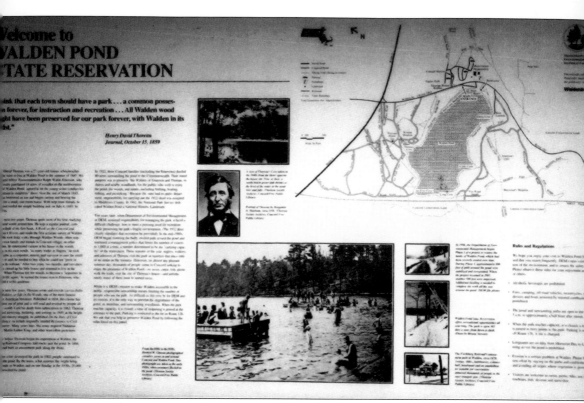

I have given myself up to nature; I have lived so many springs and summers
and autumns and winters as if I had nothing else to do but live them,
and imbibe whatever nutrient they had for me; I have spent a couple of years,
for instance, with the flowers chiefly, having none other so binding an engagement
as to observe when they opened; I could have afforded to spend a whole fall
observing the changing tints of the foliage. Ah, how I have thriven
on solitude and poverty!

The history of Thoreau's Walden, as displayed for visitors, is quite impressive.

*I think that I cannot preserve my health and spirits, unless I spend four hours a day at least—and it is commonly more than that—sauntering through the woods and over the fields, absolutely free from all worldly engagement.*

Walden seems to stand as a silent reminder of the continuing need to search for truth and divinity in the natural world. American Transcendentalism is generally agreed to date from the publication of Emerson's *Nature*, in 1836. In this essay, he wrote: "The noblest ministry of nature is to stand as the apparition of God." This sentence appears to put the concept in a nutshell.

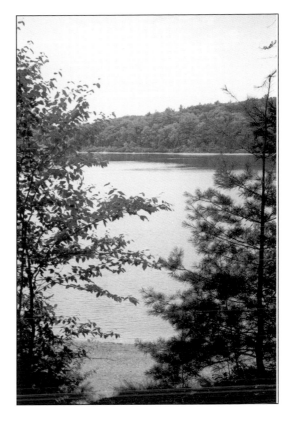

*I should have told them at once that I was a transcendentalist. That would have been the shortest way of telling them that they would not understand my explanations.*

Here is a representative selection of Thoreau's works, as displayed for sale in the Thoreau Society Shop At Walden Pond. It features *Walden*, his most famous work, in many different editions.

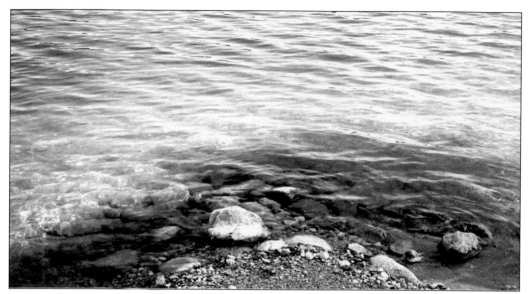

*The world is but canvas to our imaginations.*

The waters of the pond evoke peace and serenity all on their own, adding immeasurably to the inspiration of the landscape. It is an almost devout experience to walk the land, and indeed, the streets of Concord, as did Thoreau, Emerson, Hawthorne, Fuller, the Peabodys, the Ripleys, and the Alcotts.

*We must have infinite faith in each other . . . There is the same ground for faith now that ever there was. It needs only a little love in you who complain so to ground it on.*

Pictured here are the serene waters of Walden Pond, with some man-made rock formations.

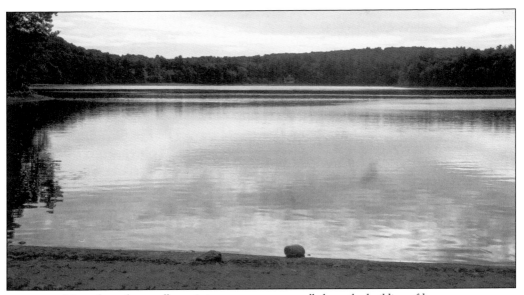

*Nowadays almost all man's improvements, so called, as the building of houses,*
*and the cutting down of the forest and all large trees, simply deform the landscape,*
*and makes it more and more tame and cheap.*

Walden at twilight is a vision so sublime as to make one feel at peace in the universal order of being. The pond stands as immutable Nature bearing witness to one man's ephemeral existence here.

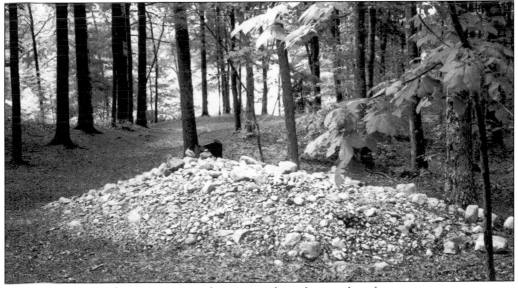

*I seek acquaintance with nature, to know her moods and manners.*

Pictured is Bronson Alcott's rock cairn looking down on the pond, exactly as Thoreau must have done for countless hours during his sojourn. He wrote, "sometimes, in a summer morning, having taken my accustomed bath, I sat in my sunny doorway, from sunrise till noon, rapt in a revery . . ." What an almost religious experience that must have been, one that we are fortunate to be able to emulate on our own quest.

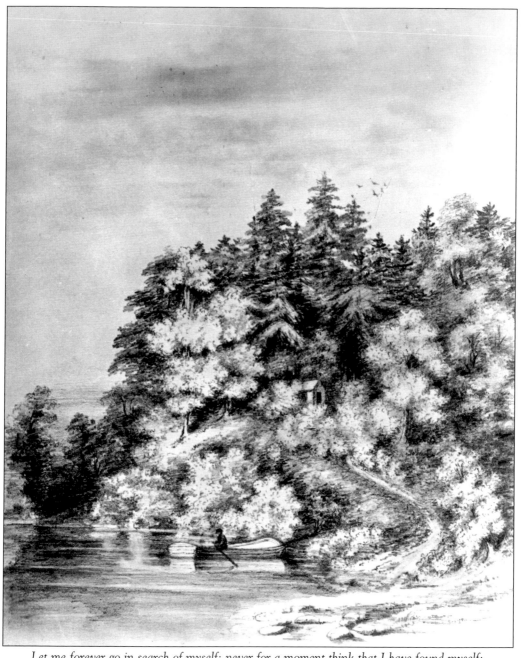

*Let me forever go in search of myself; never for a moment think that I have found myself;*
*be as a stranger to myself, never a familiar, seeking acquaintance still. May I be to myself*
*as one is to me whom I love, a dear and cherished object.*

This wonderful sketch of Thoreau and his house was drawn by May Alcott, Louisa's sister. It is easy to transport oneself back in time and be at one with the pond in all its peaceful beauty, just as he did. To spend time at the cabin site is to take a meditation, soaking up the spirit of Thoreau. When he died on May 6, 1862, a friend said that he had "never seen a man dying with so much pleasure and peace."

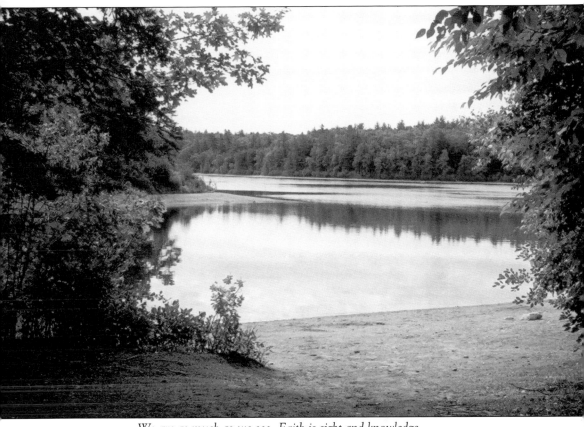

*We are as much as we see. Faith is sight and knowledge.*

This is a view of Walden from Thoreau's Cove, showing the tree-filled shoreline of today. Thoreau would have seen a woodland with far fewer trees. The major improvement since Thoreau's time is the fullness of the tree line. The reason for the relative sparseness of trees in the early 19th century was the need for firewood to heat the many large houses in Concord.

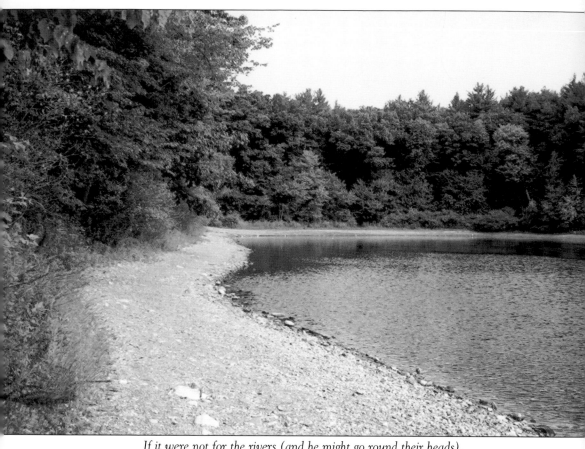

*If it were not for the rivers (and he might go round their heads),*
*a squirrel could here travel thus the whole breadth of the country.*

There are some purists who would take away the public beach and beach house in order to return the pond to the so-called "pristine" state of Thoreau's time. That, however, would mean cutting down trees. Pilgrims who sojourn at the pond and in the town of Concord can still connect with America's cultural and literary heritage, regardless of other usage.

*He will put some things behind, will pass an invisible boundary; new, universal, and more liberal laws will begin to establish themselves around and within him; or the old laws be expanded, and interpreted in his favor in a more liberal sense, and he will live with the license of a higher order of beings.*

In 1922, the Emerson, Forbes, and Heywood families granted about 80 acres around the pond to the Commonwealth of Massachusetts for the purpose of "preserving the Walden of Emerson and Thoreau, its shores and nearby woodlands for the public who wish to enjoy the pond, the woods, and nature."

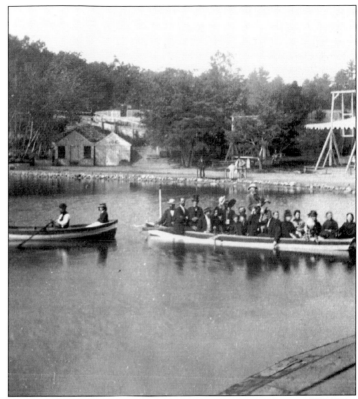

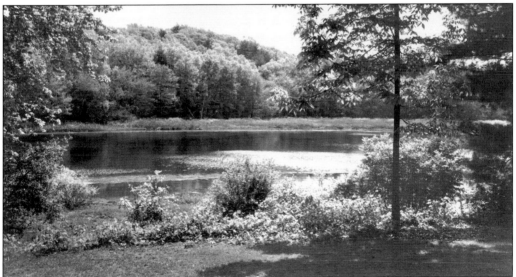

*To attend chiefly to the desk or school-house, while we neglect the scenery in which it is placed, is absurd.*

Fairhaven Bay, adjacent to Walden, was another place of inspiration for Emerson and Thoreau on their walks together. In September 1847, Thoreau completed his experiment in simplicity and became a sojourner in civilized life again. What he had achieved at the pond would reverberate down through history and become more relevant to each successive generation.

*When I see only the roof of a house above the woods and do not know whose it is, I presume that one of the worthies of the world dwells beneath it, and for a season I am exhilarated at the thought.*

A little over 150 years ago, Thoreau wrote of agrarian scenes of pastures, grainfields, and farmland. Then, 80 percent of Massachusetts's land had been cleared for farming, firewood, building, and lumber. Today, the same scenery is very different: a vista of forests. Thoreau did not know many true forests in his time. All the more amazing that he was able to develop such an elaborate theory regarding the succession of forest trees.

*The charm of the Indian to me is that he stands free and unconstrained in Nature, is her inhabitant and not her guest, and wears her easily and gracefully.*

Nature's wildness was Thoreau's inspiration; this little meadow, called Wyman Meadow, sits beside the pond right next to his house. The wildlife that he wrote so much about is now mostly gone. He waxed lyrical about birds of the field and marsh: the bobolinks, meadowlarks, song sparrows, bluebirds, and bitterns.

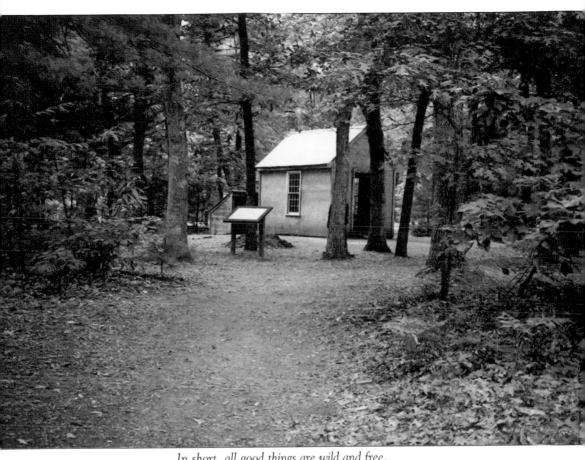

*In short, all good things are wild and free.*

## The Thoreau Society

Established in 1941, the Thoreau Society is the world's oldest and largest professional society devoted to the legacy of an American writer. The Thoreau Society adheres to the mission of honoring Henry David Thoreau by stimulating interest in and fostering education about his life, works, and philosophy, and his place in his world and ours; by coordinating research on his life and writings; by acting as a repository for material relevant to Thoreau; and by advocating for the preservation of Thoreau country. The society collaborated with the Walden Woods Project to create the Thoreau Institute at Walden Woods, a research and educational center near Walden Pond. Under an agreement with the Massachusetts Department of Environmental Management (DEM), the society is also the Commonwealth's official "friends" organization for Walden Pond. Through programs that include public education and environmental conservation, the society's Friends of Walden Pond Committee promotes management activities, jointly developed by DEM and the society, that balance resource protection and enhancement with public use and enjoyment at the Walden Pond State Reservation.

For more information about the Thoreau Society and its programs and for membership information, write to the society's administrative offices at 44, Baker Farm, Lincoln, MA 01773, USA, call (781) 259-4750, or e-mail ThoreauSociety@walden.org.

## The Walden Woods Project

A publicly supported charity founded in 1990 by recording artist Don Henley, the Walden Woods Project has evolved into a highly regarded and successful conservation organization dedicated to protecting and restoring land in and around Walden Woods. This area, west of Boston, which inspired much of the philosophy and writings of American author and conservationist Henry David Thoreau, is widely acknowledged to be the cradle of the American environmental movement. The Walden Woods Project is continuing to protect and restore land within this historic ecosystem, and in 1998, opened a research and educational center near Walden Pond. The Thoreau Institute at Walden Woods, a collaboration of the Walden Woods Project and the Thoreau Society, houses the society's incomparable collection of Thoreau-related material, maintains a comprehensive database of information relevant to Thoreau and to land protection and restoration, and offers a wide variety of environmental humanities-based programs for teachers, students, and lifelong learners.

To learn more about the Walden Woods Project and how you can support its mission, or about the Thoreau Institute at Walden Woods and its programs, write to the project's administrative offices at 44, Baker Farm, Lincoln, MA 01773, USA, call (781) 259-4700, or log on to www.walden.org.